COLOR AND LIGHT
FOR THE WATERCOLOR PAINTER

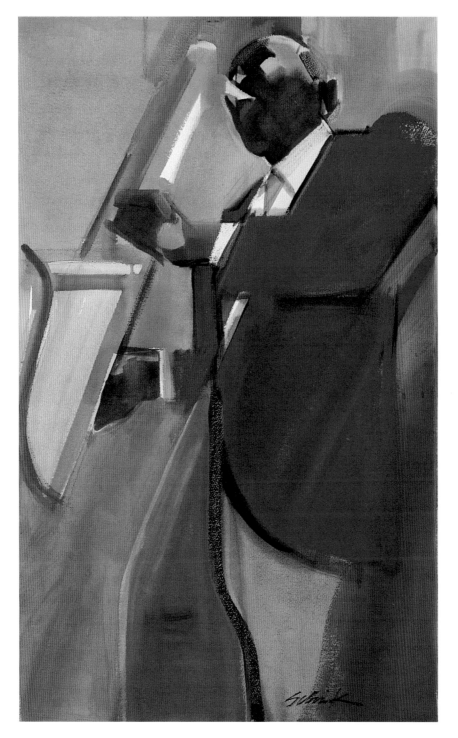

COLOR AND LIGHT
FOR THE WATERCOLOR PAINTER

HOW TO GET THE EFFECTS YOU WANT EVERY TIME

CHRISTOPHER SCHINK

WATSON-GUPTILL PUBLICATIONS
New York

To my brother, Peter

Half-title page:

Christopher Schink
MAGENTA TENOR
Watercolor and acrylic on paper,
24 x 38" (61 x 96.5 cm)
Collection of the artist

First published in 1995 in the United States by Watson-Guptill Publications,
a division of BPI Communications, Inc., 1515 Broadway, New York, NY 10036-8986

Library of Congress Cataloging-in-Publication Data
Schink, Christopher, 1936-
 Color and light for the watercolor painter : how to get the effects
 you want every time / Christopher Schink.
 p. cm.
 Includes bibliographical references and index.
 ISBN 0-8230-0686-7
 1. Watercolor painting—Technique. 2. Color in art. 3. Light in art. I. Title.
ND2420.S326 1995
 751.42'2—dc20 95-22134
 CIP

Manufactured in Hong Kong

Senior Editor: Marian Appellof
Associate Editor: Dale Ramsey
Designer: Jay Anning
Production Manager: Hector Campbell

1 2 3 4 5 / 99 98 97 96 95

Acknowledgments

I would like to thank the people who helped me in organizing and writing this book: My special thanks to Edward Betts for encouraging me in this project and in my efforts as a teacher over the last twenty years; to the many fine artists who contributed examples of their work, including my close friends Alex Powers, who made some very helpful suggestions, Katherine Chang Liu, whose contributions and advice were invaluable, and Skip Lawrence, who gave me many useful ideas and his loyal support; to my father, Clifford Schink, who at ninety-two and with failing eyesight can still spot a mushy word and a meaningless sentence; to my brother, David Schink, who cleaned up my manuscript; and to Dale Ramsey, my editor at Watson-Guptill, who thoughtfully organized and edited this complicated book. I feel fortunate to have had the assistance of these talented and generous people.

CONTENTS

INTRODUCTION

Of all the graphic tools available to a painter, none is as exciting or evocative as color. With color alone—a few smears of paint—you can create an illusion of light and shadow, convey a mood of solitude or a feeling of excitement or joy, and even suggest the appearance of atmosphere and space. No element of painting is so immediately expressive, and yet no area of painting instruction is so often neglected. In art instruction, color is usually treated as an afterthought, as an entirely subjective element based on taste or intuition—in short, as unteachable, because you just "feel it." Art instructors may suggest that a sense of color is like talent—you either have it or you don't. I disagree.

In teaching painting classes, I have found that students can learn how to mix, control, and combine color. With practice they can develop a greater sensitivity to color. The more they paint, the more readily they produce the mixtures they want. However, just a trained eye and a skillful hand won't produce a work of art. They are simply the means to expressing what you think and feel.

Most of the painters I encounter in my classes have developed enough skill in color mixing to produce a great variety of the colors they desire. Their problem is not technique; where they have difficulty is in deciding where, when, and how to use their mixtures, and most importantly, in understanding why certain choices work or do not work. In this book I have attempted to provide answers to these problems, but not necessarily the infallibly right answers, and certainly not the only answers. What you have to say in your paintings should be personal and unique. Instruction shouldn't be restrictive and narrowing; it should provide you with a larger vocabulary and an greater awareness of how to employ it. It can't and shouldn't tell you what to say. For that reason, I've included many different approaches to color and described why and how artists of the past and present have effectively used color as an expressive element in their paintings. Ultimately, the choices are yours.

Painting—the process of applying various earthen, metal, and synthetic dyes to a sheet of paper with fur hairs attached to a stick—is not a natural act. Like playing the violin or writing haiku poetry, it is a learned skill that you can acquire only through study and practice.

Developing a Color Sense

If your early experiences in painting were similar to mine, most of what you first learned about color and color mixing you learned empirically. When I successfully mixed something that didn't look like mud, I used it again and again. I bought a tube of everything on the store shelf, and if I found two colors that looked good when mixed together I added them to my limited repertoire.

Mostly I was concerned with technique, control, and, occasionally, design. Color was something I threw in at the end—after I'd done my sketch, worked out my shapes, and started my first washes. My color choices were based almost entirely on the *local color* of my subject—that is, if the barn I was looking at was red, I painted it red and didn't think much more about it. I viewed color as a pleasant adjunct to shape, line, and texture, as nothing more than frosting on my cake. But the longer I painted the more I realized that color could serve as a powerful expressive element in my work.

I eventually learned about color by studying with outstanding painters and instructors—Rex Brandt, Barse Miller, and Edward Betts—and from studying the work of great colorists of the past—Leonardo da Vinci, Peter Paul Rubens, Paolo Veronese, Eugène Delacroix, J. M. W. Turner, Vincent van Gogh, Henri Matisse, and many others. I also read the works of contemporary color theorists, such as Josef Albers, Faber Birren, and Floyd Ratliff. This book assembles many of their ideas, without the jargon associated with "artspeak" but in terms and techniques that are simple and useful. I've written this book believing that painters need to understand, first, how we perceive and react to color and, second, how they can apply this knowledge in a practical and personally expressive way to the process of painting.

Van Gogh, a case in point, began his artistic career working almost entirely in deep brown shades that looked like something you get from a pot roast; he didn't seem to possess much of a color sense. It wasn't until the last two or three years of his short life that he

taught himself to use color in the original way that we now associate with him. Indeed, none of the great colorists I've mentioned above started with great color; it was something they studied and systematically learned to use.

As with other painting skills—designing shapes, organizing space, developing technical proficiency—you can learn to mix bright colors, suggest atmospheric effects, or re-create the illusion of sunlight and shadow. But like any other creative ability or acquired knowledge, color skills have to be employed for some higher purpose than merely demonstrating that you can do them. They are the means to *expressing your ideas and feelings,* not your competence. A harmonious color relationship or the convincing illusion of fog does not by itself make a creative work of art.

I have divided the instruction in this volume into five chapters: The first, "Color Mixing," describes the fundamentals of color mixing and modification. The second, "Composing with Color," is designed to help you organize color in a design that furthers your expressive goals. The third, "Perception, Light, and Color," describes how we reproduce with paint the effects we perceive in our visual world. The fourth section, "Approaches to Color," is designed to help you conceive your own approach to color; this section shows how painters from the past have employed formal color arrangements in their paintings. In the fifth section, "Color and Expression," a number of distinguished contemporary painters describe how they employ color in their work. I conclude with suggestions on how you might develop your personal color style.

Wherever I have described a theory of color perception, I have tried to use the simplest, least technical terms. I have reinforced important points in the book with appropriate illustrations and paintings, some by myself, others by a variety of outstanding artists working in very different styles. In several of the chapters I have also included a section called "Problems and Practical Considerations." There I list some of the most common problems I have identified in my students' works, followed by suggestions for solving them and some specific notes on matters of technique.

COLOR MIXING

Painting comprises three principal parts, which we say are drawing, proportion, and color.

PIERO DELLA FRANCESCA

We don't easily forget the things we learn by trial and error. That's how most of us learn to mix color, by experimenting on our palette and paper. We didn't have to name or describe the colors we made, we just made them and had no trouble remembering how. That's the obvious advantage of acquiring knowledge empirically. But like learning to play the piano by ear, unless you are truly gifted learning to mix color this way has some disadvantages: You can retain bad habits as easily as good and, because you're self-taught, you can remain unaware of what you don't know.

In this section I describe the basic techniques of color mixing and define the terminology I use throughout the book. Even if you are fairly experienced in color mixing, it's still worth a review.

From your very first painting, you learn that you don't very often want to squeeze paint straight from the tube and spread it on the paper. To get the exact color you want, you usually have to modify the paint in some way, lightening it, darkening it, or changing its intensity (its degree of saturation or brightness), or using a combination of these modifications. And you can't buy every color that comes out on the market; it's neither practical nor affordable. Where will you put all those paints on your palette, and how will you explain the bill?

To achieve the effects you want you usually have to take the limited colors you have and somehow modify them. Many of us eventually develop a workable system: If a color is too dark we add water; if it is too bright we add its *complement*, which is the color that lies directly across from it on the color wheel.

Something as rudimentary as color mixing is rarely taught, and even some experienced painters still rely on a few tried-and-true formulas without a clear understanding of how color can be modified. To begin with, we will define our terms for describing color modifications.

MODIFYING COLOR

Pure Colors

Pure colors are the colors of the light spectrum, produced when white light is refracted. These are the *primary colors,* red, yellow, and blue; the *secondary colors,* orange, green, and purple; and the *intermediate colors,* the steps between primaries and secondaries (for example, red-orange or yellow-green). In using watercolor paints, these colors are generally at their most intense when used straight out of the tube, although some of the darker pure colors will appear more intense when lightened slightly.

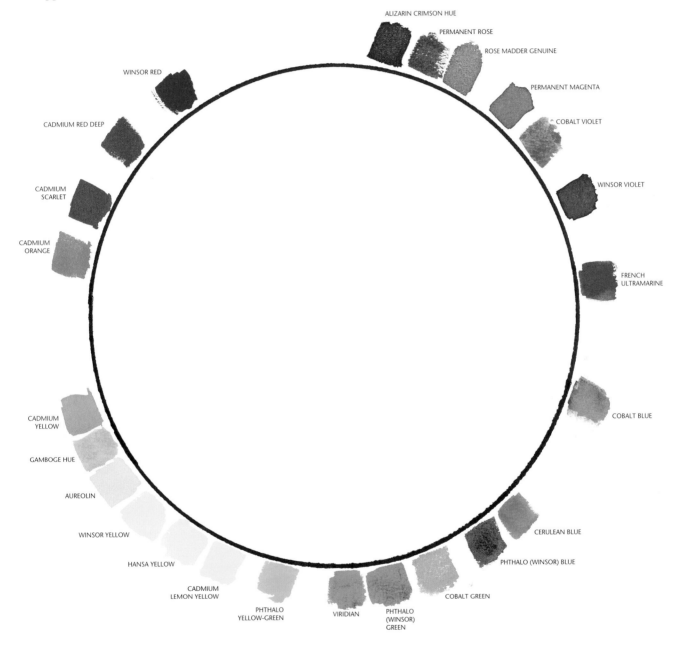

Pure color: Here is a color wheel made up of paints that approximate the colors produced when white light is refracted (as through a prism). I'm not recommending this as a palette, for it's far too large, but it does provide a list of what I think are the most useful watercolors.

Tints, Muted Tints, and Shades

Tints are simply pure colors that have been lightened by the addition of white or, in the case of watercolor, by the addition of water. We often use the term "pastels" to describe tinted colors. Tints appear light, and because they are made from pure colors, I think of them as being "clean-looking." A small amount of gray, black, or complementary color will turn them into muted tints (below).

Muted tints (sometimes called *tones*) are pure colors modified by the addition of water (or white) and a small amount of gray or a complementary color. A muted color is said to have a *neutral* appearance. For example, adding a dash of green and water to red will neutralize a red tint. Muted tints do *not* have the clean, or unsullied, appearance that tints do; they look slightly "dirty."

Shades are made by adding a small amount of black or a complement to a pure color, with little or no water or white. (If you add too much water, you'll produce a muted tint.)

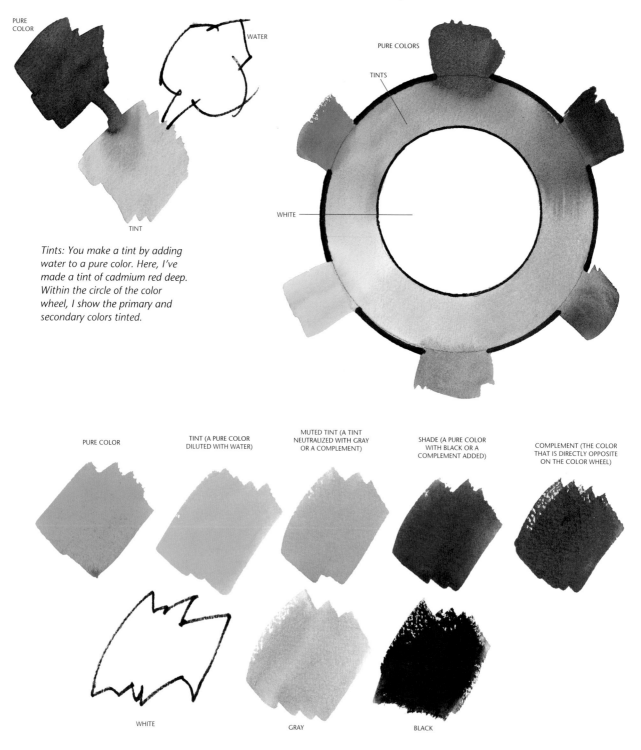

PURE COLOR

WATER

TINT

Tints: You make a tint by adding water to a pure color. Here, I've made a tint of cadmium red deep. Within the circle of the color wheel, I show the primary and secondary colors tinted.

PURE COLORS

TINTS

WHITE

PURE COLOR

TINT (A PURE COLOR DILUTED WITH WATER)

MUTED TINT (A TINT NEUTRALIZED WITH GRAY OR A COMPLEMENT)

SHADE (A PURE COLOR WITH BLACK OR A COMPLEMENT ADDED)

COMPLEMENT (THE COLOR THAT IS DIRECTLY OPPOSITE ON THE COLOR WHEEL)

WHITE

GRAY

BLACK

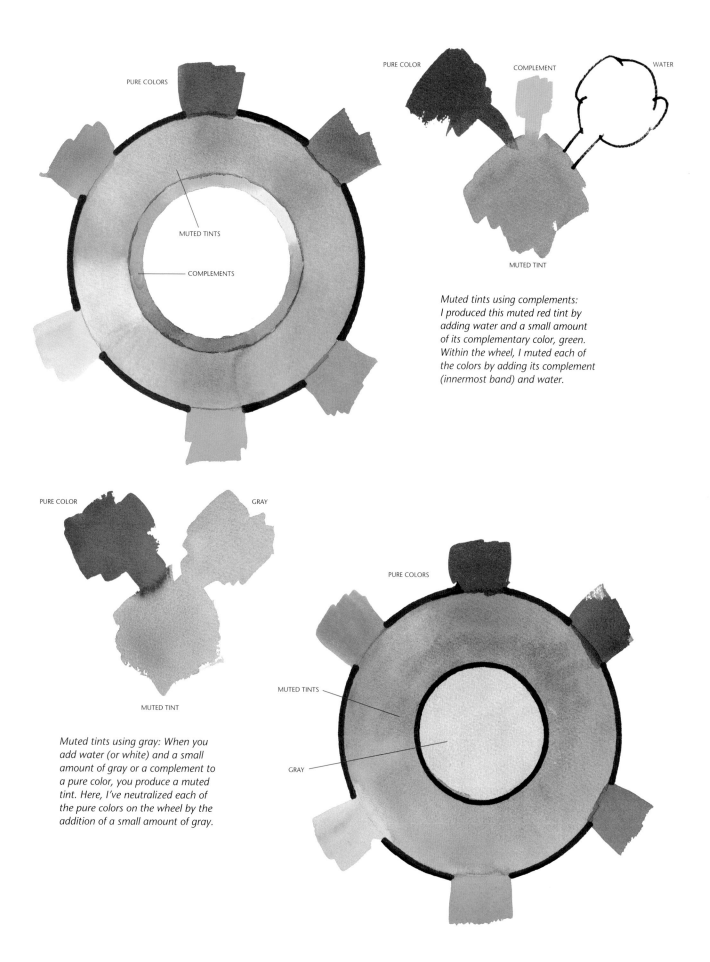

PURE COLORS

MUTED TINTS

COMPLEMENTS

PURE COLOR

COMPLEMENT

WATER

MUTED TINT

*Muted tints using complements:
I produced this muted red tint by
adding water and a small amount
of its complementary color, green.
Within the wheel, I muted each of
the colors by adding its complement
(innermost band) and water.*

PURE COLOR

GRAY

MUTED TINT

*Muted tints using gray: When you
add water (or white) and a small
amount of gray or a complement to
a pure color, you produce a muted
tint. Here, I've neutralized each of
the pure colors on the wheel by the
addition of a small amount of gray.*

PURE COLORS

MUTED TINTS

GRAY

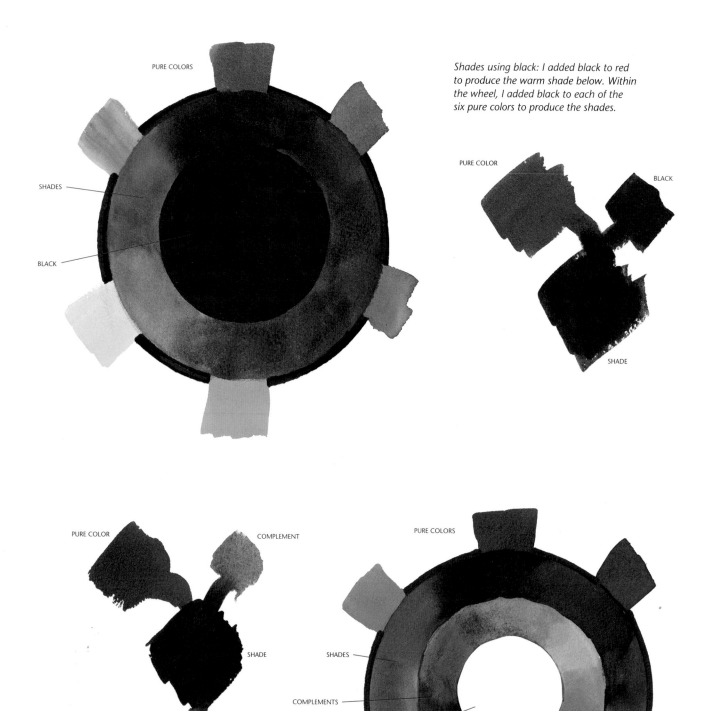

PURE COLORS

SHADES

BLACK

Shades using black: I added black to red to produce the warm shade below. Within the wheel, I added black to each of the six pure colors to produce the shades.

PURE COLOR

BLACK

SHADE

PURE COLOR

COMPLEMENT

SHADE

MUTED TINT

PURE COLORS

SHADES

COMPLEMENTS

LITTLE OR NO WATER

Shades using complements: You can easily produce a shade by adding a small amount of a complementary color (and little or no water) to a pure color. Here, for example, I've added to the red a small amount of its complement, green, to produce the shade. (Note below that I made a muted tint from the shade by adding more water.) Within the wheel, I've produced shades by darkening the six colors with their complements.

White, Black, and Gray

Of course, white, black, and gray play an important role in color. White is produced by leaving your watercolor paper unpainted or by using an opaque white pigment. Black can be obtained by mixing two complements (I like to use phthalo green and alizarin crimson), or you can use a prepared black paint. Gray is a dilution of black, or a mixture of black and white. You can use prepared gray paints as well.

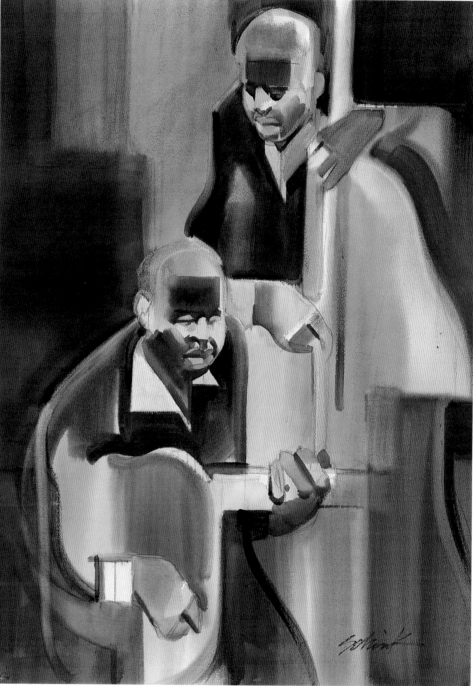

Christopher Schink
RHYTHM SECTION
Watercolor on paper, 41 x 28"
(104 x 71 cm)
Collection of the artist

I painted this jazz club scene employing tints (top) for the lightest areas; muted tints (center) for the mid-range values; and shades (bottom) for the darks. Note the difference in appearance between tints and muted tints. Tints are derived from the pure colors; muted tints are more neutral and look slightly sullied.

Modified Colors

Not all pigments are pure colors—in fact, many are not. Pigments are produced from various organic and inorganic materials, including earthen substances, carbon compounds, metals, and synthetic materials. They range from the most highly saturated pure colors to achromatic grays.

For instance, rather than tinting pure colors with water or white, you can buy paints that, because of their transparency or admixture of white, are already tints. Although a number of these have very interesting pigment characteristics, they all have one great disadvantage: They can't be darkened enough to produce shades.

You can also find paints that are already muted tints. Many contain earthen and metal pigments that produce interesting surface effects. However, they're too muted to produce clean-looking tints and often too light or opaque to be used for darkening colors to shades.

If you adopt a "traditional" color scheme (see pages 108–109) you may want several of the deeper earth colors, such as burnt sienna and burnt umber, which have served painters as shades for hundreds of years. These tend to be permanent, lightfast, and settle onto the paper with a granular appearance.

Many beginning students depend on premixed shades and grays for darkening colors. Sepia, warm sepia, indigo, Payne's gray, and neutral tint are some of the most popular. They all have one disadvantage: They contain black, a finely ground, soot-like pigment that can soil other colors.

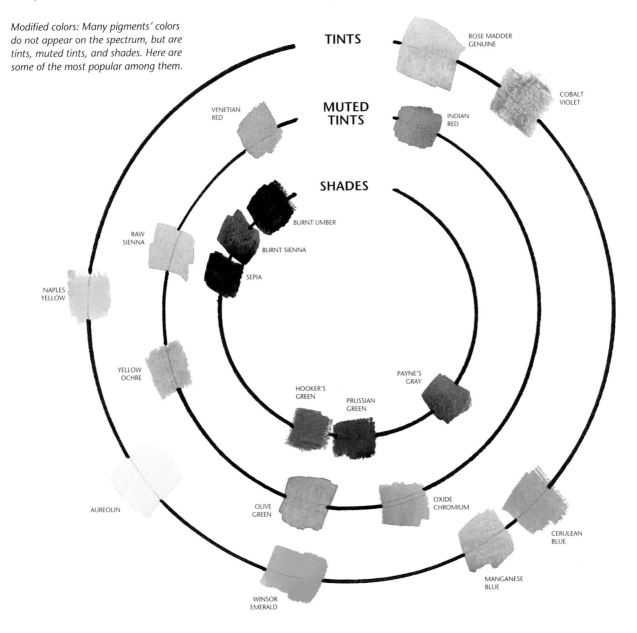

Modified colors: Many pigments' colors do not appear on the spectrum, but are tints, muted tints, and shades. Here are some of the most popular among them.

TINTS

MUTED TINTS

SHADES

ROSE MADDER GENUINE

COBALT VIOLET

VENETIAN RED

INDIAN RED

RAW SIENNA

BURNT UMBER

BURNT SIENNA

SEPIA

NAPLES YELLOW

PAYNE'S GRAY

YELLOW OCHRE

HOOKER'S GREEN

PRUSSIAN GREEN

AUREOLIN

OLIVE GREEN

OXIDE CHROMIUM

CERULEAN BLUE

MANGANESE BLUE

WINSOR EMERALD

MODELING FORM BY MODIFYING COLOR

To the untrained eye, all shadows seem neutral or gray. Ask anyone what color you should paint the shaded side of an apple or the shadows on your lawn. The answer will probably be "gray"—keep it dull and dark.

Invariably, that's how beginners paint them. They've been trained to lighten a color by adding water or white or to darken it by adding its complement. This method almost works, because it creates a change in the color's value—its lightness or darkness—and its intensity—its brightness or "saturation." But the resulting colors look cold, faded, and neutral.

To *model* an object—that is, to use light and dark to convey its three-dimensionality—you may have learned to lighten its local color with water or white and darken the local color with the addition of its complement. (The *local color* is the natural pigmentation of an object seen in normal light, without the effects of shadow, reflected color, or contrast.) You can achieve a sense of three-dimensionality this way, because of the value range you

get, but you will lose the feeling of natural illumination.

A simple set of principles was first suggested by Leonardo da Vinci concerning the lightening and darkening of colors to model three-dimensional forms:

- Where illuminated, the local color of an object appears lighter and slightly *warmer,* moving toward yellow.

- However, a change from coolness to warmth in the color (this is called a change in color *temperature*) does not occur when you lighten it with water or white; on the contrary, when you lighten it, it will appear both *cooler* and less intense. When modeling an object, you should avoid this lightened, cooler color.

- The local color on the shadowed side of an object should appear darker and cooler, moving toward violet. You should avoid darkening the color, however, by adding its exact complement, for the result is likely to appear neutral and dreary.

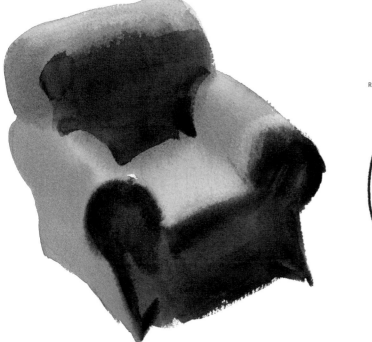

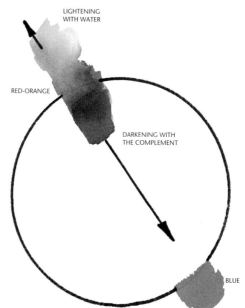

LIGHTENING WITH WATER

RED-ORANGE

DARKENING WITH THE COMPLEMENT

BLUE

To model with light and shadow, most of us learn to lighten a watercolor with water and to darken it with its complement. I started here with the red-orange of the color wheel, tinting it with water for the light areas of the chair. I created a shadow color with the addition of blue, its complement. The results look cold, dreary, and neutral—like faded upholstery.

Modifying Color Intensity

A pure color is at its most intense straight out of the tube. You reduce its intensity when you add to it any amount of its opposite on the color wheel, and when you add a large amount you greatly reduce its brightness, or intensity. Depending on the strength of the two complements, you may produce a gray, for they neutralize each other.

When you mix similar colors—say, a cadmium yellow and phthalo yellow-green—the mixture remains intense. If you combine *contiguous* colors, two colors that are next to each other on the color wheel, the mixture is as intense as possible. The farther apart two colors are on the color wheel, the less intense, and more neutral, the mixture will be. Understanding these principles will help you modify color to create a sense of light and shadow.

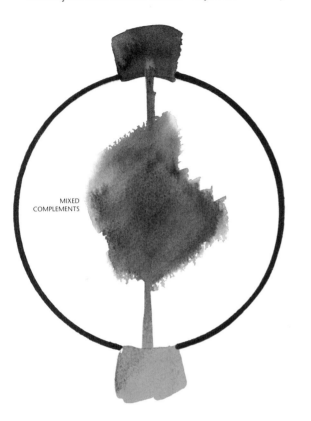

MIXED
COMPLEMENTS

Mixing complements: When you mix two colors that are opposites on the color wheel—here, red and green—the result, a neutral or a gray, has less intensity.

Mixing similar colors: The closer two colors are on the color wheel, the more intense their mixture will be. Inside the circle I started with an orange-red, adding to it first orange, then yellow, then yellow-green, and so on. As the mixed-in colors become more distant from orange-red, the mixture becomes more neutral.

Modifying Color for Vibrant Intensities

Here is a simple method you can use to lighten or darken local color, but with vibrant results:

- To *lighten* a local color—let us say red—add water or white plus a small amount of its contiguous lighter color, orange. On the color wheel, you are moving toward yellow.

- To *darken* a local color, add its contiguous darker color—in this case, you move toward purple.

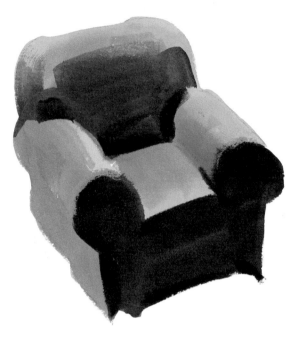

Here, for modeling the chair with contiguous colors, I lightened red-orange with water and a small amount of contiguous color moving around the wheel toward yellow (in this case, I used orange and yellow-orange). I made my shadow color by mixing with contiguous color moving toward violet (red, violet-red, and red-violet).

I've applied the same method with a green chair, adding yellow and water to lighten it. For the shadow areas, I added blue-green to darken it. Remember, when you tint a pigment it will appear cooler and less intense. You can compensate for this by adding a small amount of yellow or a similarly warm pigment.

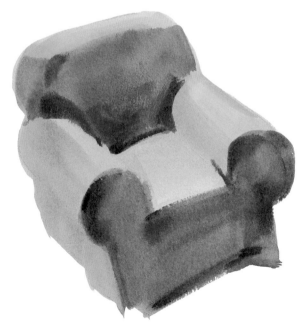

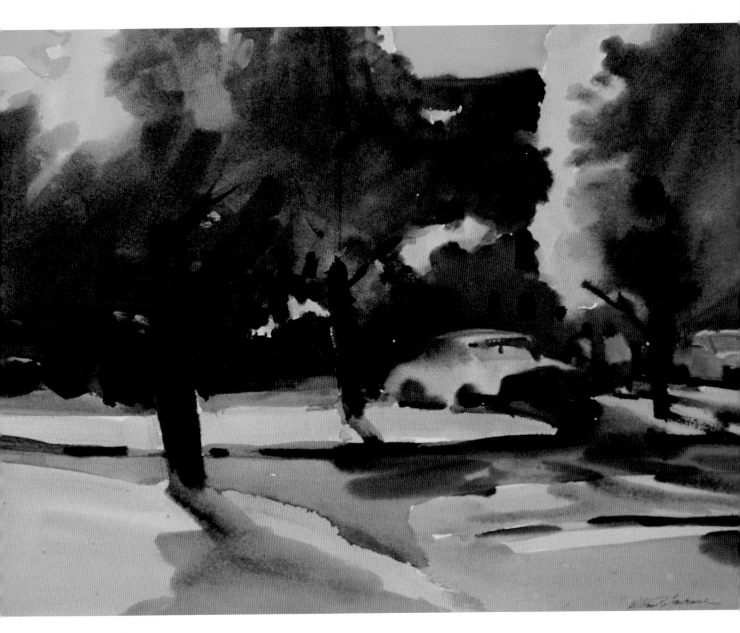

William (Skip) Lawrence
THROUGH THE TREES
Watercolor on paper,
18 x 24" (45.7 x 61 cm)

Lawrence has used pure color to model the forms in this landscape. He's painted the sunlit areas on the trees and lawn in a rich yellow-green and made their shadowed areas an intense blue-green. By using closely related greens to model the form, he achieves a vibrant effect.

PROBLEMS AND PRACTICAL CONSIDERATIONS

Problem: Muddy color

"Mud" is the term most used by inexperienced painters to describe the neutral mixtures they concoct. What I think they're describing is a neutral color that is often opaque and unvaried. To avoid mud, they may work for years with nothing but tints. Yet grays and muted tints are a vital part of many color schemes and can add great subtlety to a painting. How attractive they are depends on how you mix them.

The solution to "mud" is to create neutrals using a wet-into-wet technique. If you thoroughly mix two or three distant colors (especially light, opaque pigments) together on your palette or apply them to your paper with heavy, repeated strokes, you'll get unattractive results. If you drop the same colors onto a wet surface so that some variation in color and value results, you'll create an appealing neutral.

"Mud" is an unrelievedly dull neutral that results when you overmix three or four very different colors on your palette and apply them to dry paper with a heavy stroke, as I did on the right. On the left, I dropped the same colors—permanent magenta, viridian, gamboge hue, and cerulean blue—into a prewetted surface and allowed them to intermingle. Note the variations within the resulting neutral color area on the left.

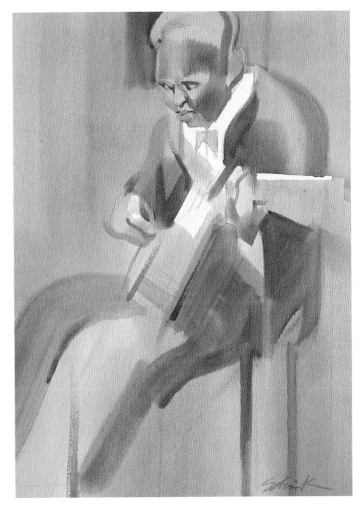

Christopher Schink
RHYTHM GUITAR
Watercolor on paper, 30 x 24" (76.2 x 61cm)

Although I painted this with a predominance of opaque neutrals, grays, and muted colors, I avoided a muddy appearance by varying colors. Note the warm, muted yellow and brown and the violet-gray.

Problem: Drab greens

Less experienced landscape painters can have difficulty mixing greens that have a natural appearance. They add water to lighten already muted or shaded greens and produce cold, drab neutrals—what I call "old sofa green."

The solution is to add yellow. Again, if you lighten a color with water (or white), it will become colder and less intense. You can easily correct this by adding a small amount of yellow or a warm yellowish color. Some landscape painters even start by underpainting areas of vegetation with a light wash of yellow.

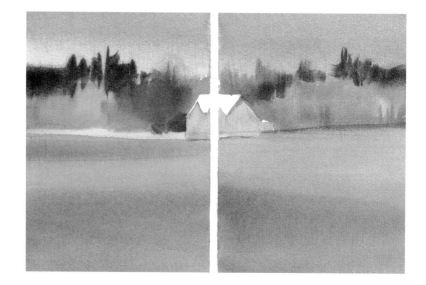

When muted tints and shades are lightened with water, as on the right side of this landscape, they acquire that drab, "faded sofa" look. On the left side, I lightened the same colors with water and a small amount of yellow. The result was more convincing and natural.

Problem: Modeling a yellow subject

Have you ever noticed how few paintings revolve around yellow? This vibrant color presents an interesting case. First of all, we have no *receptors,* or color perception cells, in the retina of our eyes for the color yellow. We have receptors for dark and light (called *rods*), and receptors for red, blue, and green (called *cones*). In a sense, we see yellow only by default. (For more on color perception, see page 48.)

Moreover, the paints we have available to us will not reproduce the value range in yellow that we think we see. The yellow pigments have a limited value range. Modeling a yellow subject thus presents a special problem. Although you might envision a dark yellow, you can't paint one, for anything you add to a yellow to darken it will change its hue—making it appear either too greenish or brownish to be seen as yellow. Still, you can often create the illusion of a dark yellow by charging a lighter yellow into a more neutral shadow. Or you can just avoid painting shaded yellow objects altogether!

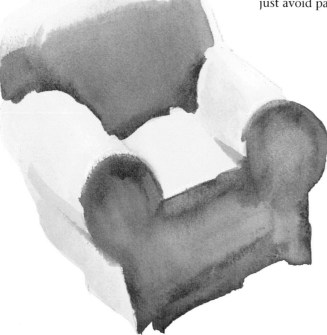

You can create the illusion of a dark yellow by charging the interior of the shadows with a lighter yellow, as I've done on the front of the chair.

Notes on Technique

You may wonder why painters bother to buy two different paints that appear almost identical—for example, cerulean blue and manganese blue. Particularly in transparent watercolors, pigments can be very close in color. But, being very different in consistency, they may not act the same when applied to the painting surface. Some pigments are very transparent; some are denser and more opaque. Some deeply *stain* your paper's fibers; others remain on the surface, creating subtle, transparent glazes. Various pigment differences mean that you can exploit certain effects, particularly when you paint wet-into-wet: granulation, color separation, and fluid intermingling. These are the characteristics that make the medium so attractive and challenging.

I hold two colors directly responsible for ruining more beginning students' paintings (and a lot of professionals') than any other paints ever produced: alizarin crimson and phthalo blue. Two of the most powerful stains available, these are spectrum colors that absorb or overpower almost every color mixed with them. When you combine them with anything but contiguous colors, you produce a flat, inky dark that is singularly unattractive.

I recommend avoiding these powerful stains in modeling, however useful you may find them in other applications. To attain darks for shadowed areas in your paintings, stick with the method of mixing I describe above. If you practice modeling with a variety of darks that retain color intensity, you'll see the difference and shun mixtures involving these stains.

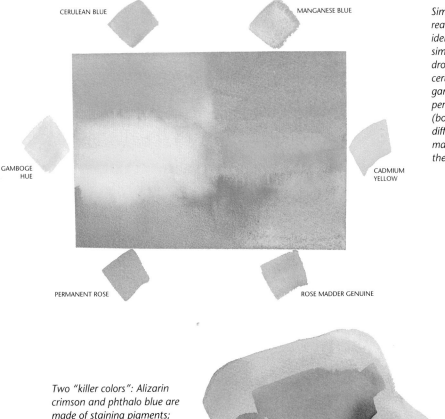

CERULEAN BLUE

MANGANESE BLUE

GAMBOGE HUE

CADMIUM YELLOW

PERMANENT ROSE

ROSE MADDER GENUINE

Similar colors, different characteristics: The reason painters buy several paints of almost identical color is that although they look similar they don't behave similarly. Here I've dropped three pairs of similar colors—cerulean blue and manganese blue (top); gamboge hue and cadmium yellow (middle); permanent rose and rose madder genuine (bottom)—onto a wet sheet. Note the differences, such as the granularity of the manganese blue and the smooth fluidity of the gamboge hue.

Two "killer colors": Alizarin crimson and phthalo blue are made of staining pigments; when mixed with other colors or used for shading, they produce inky, neutral darks with little or no recognizable hue. Compare this easy-chair example with those in which vibrant modeling colors were mixed from contiguous colors.

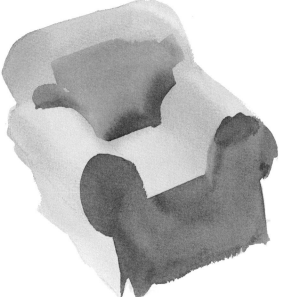

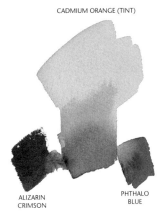

CADMIUM ORANGE (TINT)

ALIZARIN CRIMSON

PHTHALO BLUE

2 COMPOSING WITH COLOR

Composition is the art of arranging in a decorative manner the various elements at the painter's disposal for the expression of his feelings.

HENRI MATISSE

olor and color composition are the vocabulary and syntax of painting. With practice, you can learn to mix powerful darks, glowing lights, and subtle, muted colors. You can expand your color vocabulary and increase your skill in the mixing of colors.

To use the vocabulary effectively, you must learn to *compose* with color in a satisfying and meaningful way. In this section, I describe the color qualities inherent in a successful painting composition. With enough experience, you will become more sensitive to the visual forces in a painting and more adept at arranging them in a harmonious order. The colors you mix will convey and reinforce what you want to say in your painting.

Are there any rules of design that you can *always* apply in composing with color? Are there surefire laws that you can follow in selecting colors? Better yet, is there a color wheel designed to answer all your questions? Unfortunately, no. Painting is an art, not a science; there are no absolutes. You can learn some simple, basic principles of design to understand how we respond to a painting and what qualities are inherent in a good design—something that most experienced painters have learned to achieve intuitively. These design principles provide you with a place to start.

Your first objective is to draw the viewer's eye to the work for a long enough time to communicate its expressive message to him or her. Thus, you have to design a painting that holds one's attention. To achieve this, you must create a sense of unity—a wholeness of design. You must also provide sufficient variation and contrast in that design to entertain, stimulate, and direct the viewer's interest. The degree of unity, variation, and contrast you establish in that design depends on your expressive intent.

PRINCIPLES OF COLOR ARRANGEMENT

To begin, let's outline the most basic principles of design that involve the arrangement of color. Awareness of these principles will help you to organize the colors in your paintings as well as the other design elements you bring to your work.

- Repetitions of a color, and even of value and intensity, give unity to a design.

- Within a unified design, some variety is essential for interest.

- The eye is especially attracted to contrasts in value, color, and intensity. Sharp contrasts—for instance, light against dark—can be building blocks in a strong design.

- Alternations in value, color, and intensity will invest your design with rhythm, always a strong design element.

- Progressive shifts in value, color, and intensity also give structure to your design.

Study the illustrations that follow to see how these principles work in isolation. Then we'll explore the principles in more depth, beginning with ways of giving unity and variety to your work.

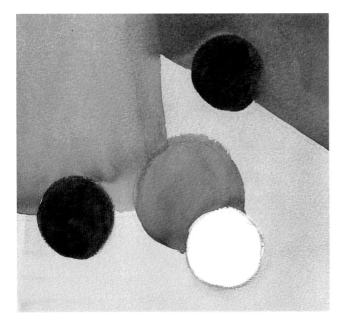

Value contrasts: The eye is most strongly attracted to contrasts in value and moves from dark to light. Here, it will travel to the light sphere immediately.

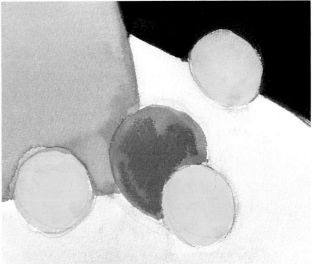

Color contrasts: Attracted to warm more than to cool colors, the eye is drawn to the "hot" orange sphere more than to the cooler green ones.

Intensity contrasts: Brighter, more intense colors grab the attention more than neutrals do. Thus the eye moves from the olive-gray spheres to the blue-green one.

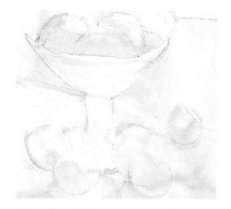

Alternating lights and darks, as in the contrasting halves of side-by-side peaches, add a rhythmic structure to a picture.

Alternating color is a way to strengthen your design. Here, magenta and blue-green tints shift back and forth over the forms.

Alternations in intensity, as in the pattern of changes from an olive neutral to brighter sap green, impart a color design to your work.

In a progressive arrangement of values, you shift in stages from dark to light. The arrows indicate the movement.that this establishes in the design.

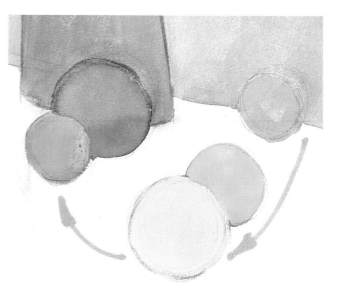

Here, colors are arranged in a progressive movement of temperature. These tints of pure color are placed so that the eye will move across the design from cool to warm.

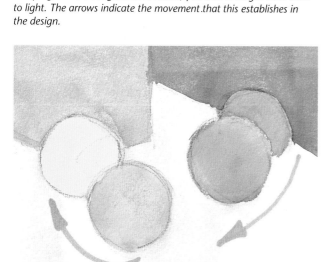

Colors arranged in progressive shifts establish a movement also. Here, the design progresses in intensity—from dull gray-green to yellow-green to bright lemon yellow.

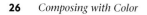

Unity and Variety

As noted above, by repeating a color—or even some quality of color such as value or intensity—you can unify a design. This repeated quality becomes the dominant one in your painting and brings visual coherence and a sense of completeness to it. In organizing color you'll find it far easier to begin by developing some degree of unity before introducing the variations and contrasting elements.

Without some variety, unity quickly becomes monotony. You can always heighten interest in your painting by using similar, but not identical, qualities, including those of color. Try varying the range of colors, the range of lights and darks, or the degree of color intensity you use. Contrasts are dissimilar elements that create interest and focus, and we'll consider them separately.

Christopher Schink
MORNING HARBOR
Watercolor on paper, 22 x 30" (55.9 x 76.2 cm)

I've reduced the design of this painting to three values: light, middle-light, and middle. With the exception of the white, the color is muted. There are also three major shapes— the light on the boats, the shadows and reflection, and the water. The design is thus unified, but it's almost too simple, so I varied the color temperature from cool to warm within these shapes to keep the picture from becoming monotonous.

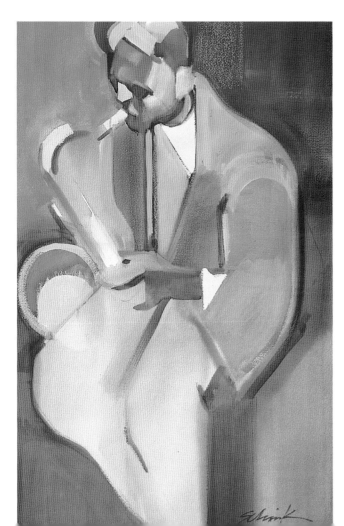

Contrast

Since by repetition you create a sense of unity, by introducing a dissimilar element you direct the viewer's eye to that element. In psycho-physiological studies of visual perception, researchers have confirmed that the eye is more attracted to light areas than to dark areas; more attracted to intense color than to neutral color; and more attracted to warm areas than to cool areas (see pages 25–26). Painters have known this instinctively for centuries and used this knowledge in organizing the color in their paintings. By carefully placing areas of contrast—a light spot in a predominantly dark area, a red barn in a mostly green landscape, an intense color in a mainly muted still life—and by adjusting the *degree* of contrast, you can control both the sequence in which the visual elements of the painting are viewed and the amount of attention they will get.

Christopher Schink
WEST COAST COOL
Watercolor on paper, 38 x 24" (96.5 x 61 cm)

I used a repetition of color to create unity in this painting. I painted most of it in warm, related colors, from orange to red to violet. Then, for contrast, I juxtaposed complements of green-yellow and violet with slightly stronger differences in value. This use of contrast draws the eye to the face and hands of the figure.

Edward Betts

GLACIAL FLOW
Acrylic on fiber board, 29 x 29" (73.7 x 73.7 cm)
Collection of the artist

In this dramatic painting done in acrylic, Edward Betts uses strong contrasts of value to direct and move our attention in a zigzag through his design. Unity is achieved by limiting his color range to variations of blue and white, and contrast is added with a deep red at the bottom. The results suggest to me the powerful and unpredictable forces of nature.

Rex Brandt

PIRATE'S COVE
Watercolor on paper, 15 x 22"
Collection of Mr. and Mrs. Douglas Smith, Tulsa, Oklahoma

Rex Brandt painted this picture with only vermilion and viridian, two complements, and he creates unity by working in predominantly muted mixtures that are close in value. He varies the color temperature from warm to cool and then draws our attention to the central area with a few carefully placed accents of pure color and strong value contrast.

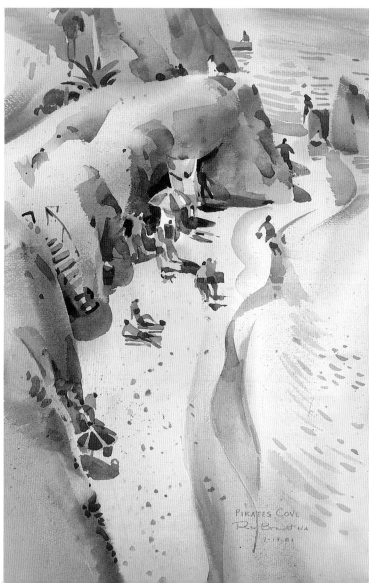

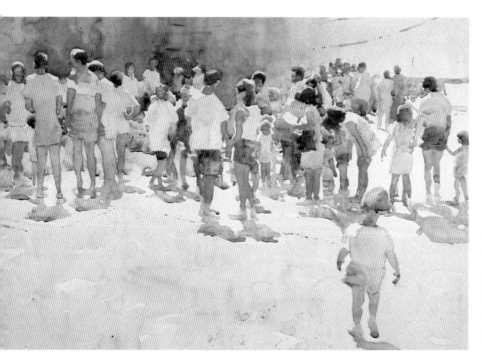

Judi Betts
SOME EYES OF TEXAS
Watercolor on paper, 22 x 30" (55.9 x 76.2 cm)

In this painting, Judi Betts keeps both the color range and the intensity range limited and directs our attention by contrasts in value. The eye is drawn to the light area, the steer's head in the upper left center, more than to the darks.

Christopher Schink
SOLO IN GRAY
Watercolor and acrylic on paper, 24 x 26" (61 x 66 cm)
Courtesy of Harbor Square Gallery, Camden, Maine

Contrasting intense color against neutral, I direct the viewer's attention in a predominantly gray painting to the yellow instrument, the violet shirt, and the red-orange accent in the musician's cheek.

Anne Adams Robertson Massie
JAMES RIVER FESTIVAL IV
Watercolor on paper, 22 x 30" (55.9 x 76.2 cm)

Notice how, even in an active composition, your eye is drawn to the intense, warm color of the central figure's shorts. Warm color is more attention-getting than cool, and intense or pure color is more eye-catching than muted or tinted color.

Rhythmic Structure

Rhythm is an important principle of design that you can apply to the organization of color to create a kind of visual movement that attracts the eye. One kind of rhythm is created by alternating color qualities like value and intensity. In other words, two or more of these color qualities appear and reappear, one after the other, over the entire design, creating a predictable back-and-forth pattern.

Another kind of rhythm is achieved by progressive changes in the use of a color quality. A movement is implied, for example, if you structure a painting with changes in value, so that the eye moves from a dark value to lighter and lighter gradations of a color, in a progression. Similarly, a progression of changes in color can be established, so that the eye travels from a cool violet, say, to a red and then finally to an orange-red.

Carolyn Lord
DOMENICA IN SCHEGGINO
Watercolor on paper, 20 x 26"
(50.8 x 66 cm)

By alternating light, middle, and dark values on the vertical shapes of her design, Lord creates a strong visual rhythm in her painting. She achieves a sense of unity by repeatedly using muted color.

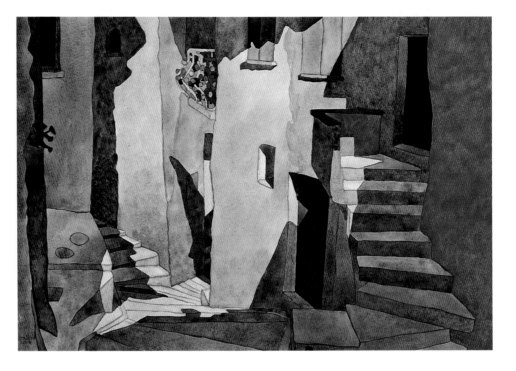

Margaret Warren-Wiese
CYPRESS CREEK
Watercolor and casein on paper,
22 x 30" (55.9 x 76.2 cm)
Private collection

In repeated verticals, Warren-Wiese has created a feeling of rhythm by alternating warm and cool tints and muted tints in slightly different values. These alternations of color temperature and subtle variations in value give her painting a contemporary look.

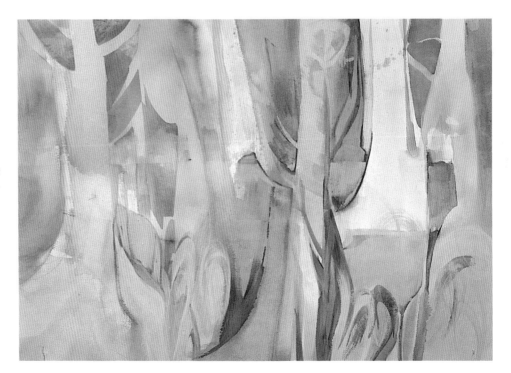

Achieving a Balanced Composition

You'll find written instructions on how to balance the color in a painting about as useful as written instructions on how to ride a bicycle. As in learning to balance yourself, you simply have to practice and get the feel of it, becoming conscious of the visual forces in a painting that attract and, like gravity, pull your eye. With practice, you become more sensitive to these forces and more able to compose them in a cohesive and balanced design.

In organizing color, there are two basic ways we achieve balance: symmetrically and asymmetrically.

Symmetrical balance is one in which colors, shapes, value contrasts, and so on are equally and evenly distributed. This kind of composition is immediately satisfying and easy to comprehend, but it is formal-looking, a bit rigid, and not particularly entertaining. Artists rarely organize color in a perfectly symmetrical design (unless they're designing oriental carpets), but to achieve a certain effect you might introduce some variation into a balanced design.

Asymmetrical balance is an uneven but harmonious distribution of visual elements. This more common type of arrangement is almost impossible to quantify or describe, for too many factors affect our perception. All one can say is that when organizing color you must be conscious of the proportion and interaction of your colors, value contrasts, and color intensities. You learn to arrange these elements by repeated trial and error. And no matter how long you've painted, you will still find it a challenge and a struggle.

I have included my painting *Rehearsal* to illustrate, in the simplest of terms, the complex process of balancing a design. It is the contrast of elements that attracts and directs the viewer's eye. Working in watercolor, with some acrylic additions, I designed an asymmetrical pattern of dark shapes, with a secondary design of smaller shapes of light. I surrounded these with a fairly well balanced pattern of red-orange in the empty spaces surrounding the forms. I didn't work out these arrangements beforehand with a careful plan; I simply "felt it," responding to the visual whole as I attempted to balance each new element I introduced into the painting. The breakdown illustrated here came later.

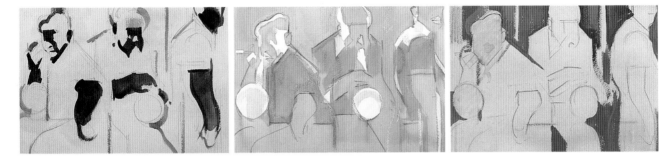

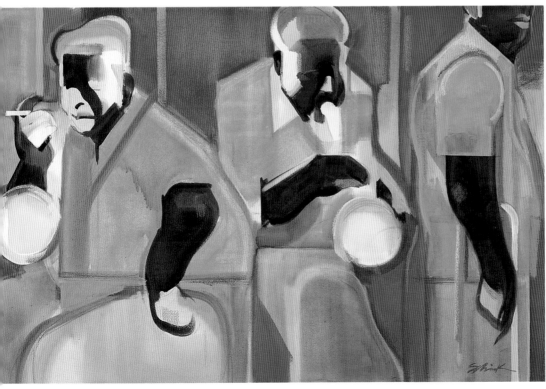

Balance, the arrangement in a harmonious order of the visual elements in a painting, is difficult to achieve. I balanced warm, dark shapes (top left) with a few contrasting light shapes (middle). And in the surrounding space (right) I tried to create a balanced design with a slightly muted red-orange.

Christopher Schink
REHEARSAL
Watercolor with
acrylic on paper,
28 x 44" (71.1 x 111.7 cm)

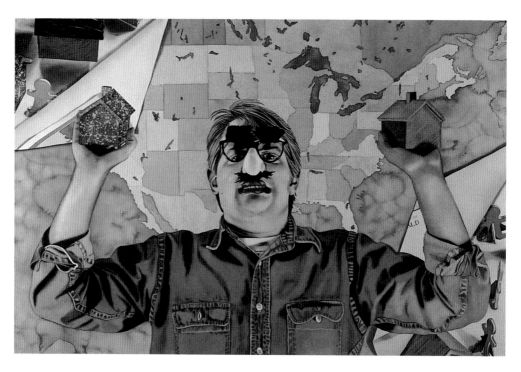

Elizabeth Yarosz
ATLAS
Watercolor on paper, 40 x 60"
(101.6 x 152.4 cm)

The formal, almost symmetrical distribution of color and shape in this painting, combined with its idiosyncratic subject matter, gives it a compelling, eccentric quality. Our attention is held by the variations—subtle differences between the right and left side of the image.

Your Design Process

You might conclude after reading this chapter that composing with color in a painting is a little like assembling a model airplane by following the directions: Glue together the framework, add the engine, attach the propeller, and it will fly.

Unfortunately, it's not that easy. The elements of design are not parts you deal with one at a time; you don't paint your subject matter and then add contrast and rhythm. These elements are really just our descriptions of abstract qualities that are present in an effective painting. Color composition requires that you consider and develop the painting, whether realistic or nonobjective, as an integrated whole.

So keep asking as you are painting: What attracts my attention; where does my eye go; what seems monotonous; what feels discordant?

Glenn Bradshaw
COORDINATES II
Casein on rice paper, 37 x 57"
(94 x 144.8 cm)

The elements of design—unity, variety, contrast—are all present in this beautifully orchestrated abstraction painted in casein, a water-thinned paint with a milk-protein base. By repeating and varying warm colors in similar values, artist Bradshaw unifies his design. He then attracts our attention with the contrasting white gestural stroke and dark shape in the lower right. The contrast of the blue stripe leads us to other areas in the painting, such as the smaller box in the upper right and the swooping shape on the left.

PROBLEMS AND PRACTICAL CONSIDERATIONS

Problem: "Because it was there" composition

I find that students in my classes have a far better sense of color balance than they realize; they just forget to exercise it. They include a bright red rose in the upper right corner of their painting or a purple fishing boat in the lower left "because it was there" in the actual scene they were painting. The problem is that you can't rely on the subject *as is* to provide balanced and effective color and design.

The solution is to create a coherent design plan, with a quick sketch, a watercolor study, or a strong mental concept, to attract and hold attention. The viewer doesn't care where the purple boat was anchored or even that it was purple, but only that the visual elements in the painting are satisfying. It's up to you.

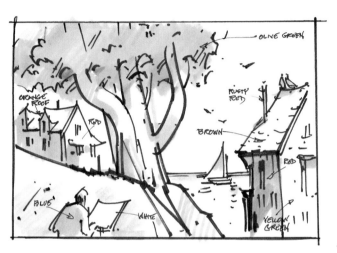

I was attracted to the play of light and shadow on eucalyptus trees on the California coast, but in my first sketch I included everything in sight, along with color notes. The shack, the house, the fellow artist ahead of me—all help fill the picture with color but do not improve the composition. I sketched them "because they were there."

In my second sketch, I composed a simple and direct painting. I noted the illuminative effects I had originally wanted and eliminated all peripheral elements. Nobody will know or care that there was a foreground shack in the actual scene.

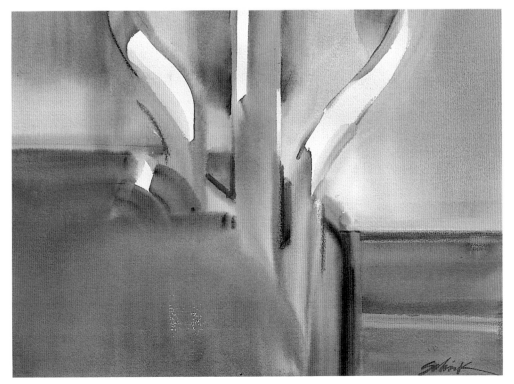

Christopher Schink
CALIFORNIA COAST
Watercolor on paper, 22 x 30"
(55.9 x 76.2 cm)
Private collection

Problem: Too much of a good thing

Contrast is one device that beginning painters learn to rely on. If a little contrast—a strong dark against a light, or a red next to a green—peps up their paintings, then a lot, they conclude, will be even better.

The solution, of course, is to understand the artistry in restraint. Strong contrasts will attract the viewer's attention, but if they don't fit the subject or are overused, they'll seem too flashy or theatrical.

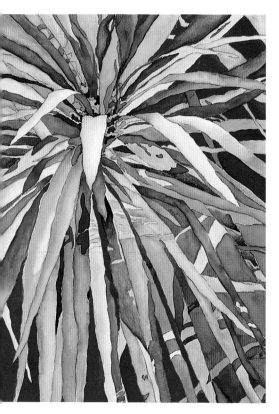

At my request, Mary Cox painted this tropical motif twice. With little structural planning, she employed a high degree of contrast that really doesn't suit the subject (above).

With artistic forethought, Cox painted the restrained, nicely designed version shown at right. The subject is a complicated and busy one, so she unified her design by repeating similar colors and values and keeping contrast to a minimum.

IDENTIFYING YOUR EXPRESSIVE INTENT

As you begin a painting, you have to decide which colors to use. Are you going to try to duplicate accurately the local colors of your subject, or are you going to change them? And if you are going to change them, how are you going to do so and why? These decisions should be based on your expressive intent: what you're trying to say in your painting.

If you are a beginning painter, you may be satisfied just to record "what I saw today." Your intent is to be descriptive and accurate; changing colors seems almost dishonest. Besides that, painting is never easy, and you have other concerns: Did I draw the subject accurately; is the composition good; did I remember to bring lunch?

A beginning painter's alteration of an object's local color may be the result of poor technique, rather than of artistic choice. As you become more experienced and technically skillful you become less satisfied with a dutiful reproduction of a scene or object. You want to make creative changes and say something more personal about your subject.

Painting with a Direction

Without a doubt, identifying why you want to paint something and what you want to say about it isn't easy. We rarely put our initial reaction to a subject into words, except to say, "I like this," "That's beautiful," or just "Wow!" Words are insufficient in describing visual experiences. But the hard job of identifying what you want to communicate to the viewer, whether you are painting realistically or nonobjectively, is the first step in the creative process.

Color is an important element in describing what you think or feel. If you're not clear on what you want to express in your painting, or if you lose touch with what you started out to say, the color (and everything else) in your painting will suffer. Without a direction you'll end up just filling in the spaces. Determine the direction you're going to take *before* you begin painting.

Some painters find a direction by taking a "content follows form" approach and begin a painting by allowing pigments to mix and intermingle with no preconception of form or color. They eventually identify some expressive quality or mood and emphasize it through selection or further manipulation of the color and design.

You may not choose to work in such a subjective way. Instead, you might take a *perceptual* approach, basing your color choices on a specific light or color quality you have observed. Possibly, you may prefer a *conceptual* approach based on a more formal, preconceived color scheme. Or you may even decide to work intuitively with color, in an entirely *emotional* way. Most likely, you will use some combination of the three.

Now let's generally examine these ways of approaching color. Later, we'll deal with more of the specifics in Chapters 3 and 4.

Perceptual Color

Basing your color choices on what you see is an obvious approach, and an acceptable one. The simplest way to describe the colors you perceive is to ignore the effects of light and shadow or of atmosphere and distance on your subject and record only its local color—blue sky, green grass. The results can be childlike and decorative, reminding us of primitive painting. Many aspects of perceptual color—the role of light, pictorial space, atmospheric effects, and so on—will be discussed in depth in Chapter 3; for now, let us lay the groundwork.

Local Color Though often inspired initially by a particular color relationship, few contemporary painters base their approach solely on the accurate depiction of local color. If you do employ descriptive color, you should be clear and selective as to what *particular* color quality you are describing. For instance, if it is a color relationship you find attractive—the effect of a red roof against the deep green of the trees beyond—you should deliberately compose your color to emphasize that relationship. On the other hand, if you find an illuminative effect more exciting—the play of violet shadows on a white building— that should be the basis of your color choice. Give yourself a definite direction to go in. All your design decisions— what you include or eliminate, what you emphasize or subdue—should be based on conveying a quality. The following illustrations show some possibilities with a traditional landscape subject, a white lighthouse in Maine.

Illuminative Effects With local color we record the surface color of objects, but with illuminative effects of light and shadow we describe their form. No element of our visual world has so occupied the interest of painters as the play of light and shadow on form or simply the color

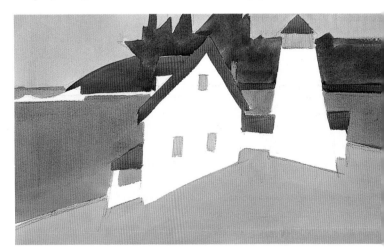

Capturing local color: In this case you describe only the surface color of objects without certain effects of illumination, aerial perspective, or atmosphere. Here, the lighthouse is stark white, without even a shadow.

and quality of light itself. Beginning in the Renaissance, this interest prompted artists to use a predominance of shadow in their work. Leonardo emphasized light and shadow (*chiaroscuro*) as a means of modeling form. Titian, Caravaggio, and Rembrandt developed his ideas further and combined strong illumination with deep shadows to infuse their compositions with drama. In the 19th century, painters' interests changed, and their works showed a predominance of light. Turner conveyed the illusion of luminosity in highly original ways. For Impressionists like Claude Monet, the primary interest was in the play of color in light and shadow.

Polly Hammett
THE SISTERS
Watercolor on paper,
22 x 30" (55.9 x 76.2 cm)
Private collection

Local color, the surface pigmentation of objects seen in normal light without the effects of shadows, reflections, and the like, represents a simple and sometimes naive choice to describe a subject faithfully. Here, Hammett employs local color in a sophisticated pattern of shapes that have a flat, contemporary look.

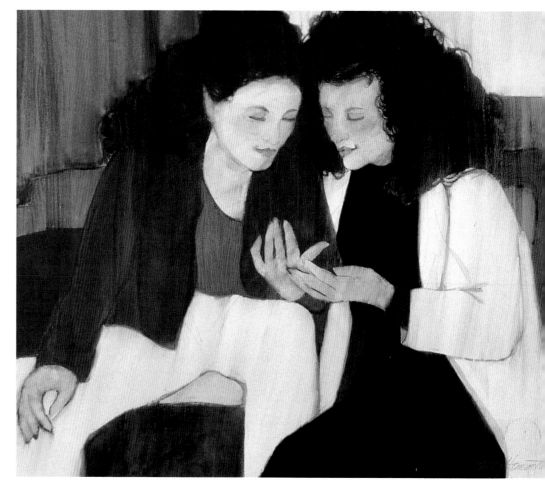

Illumination and color: Here, local color is altered as emphasis is given to effects of light and shadow. Note that on this white house there are yellows and violets where the shadow of the roof falls.

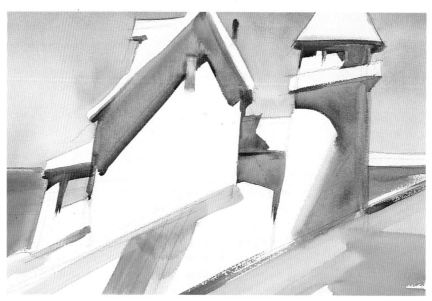

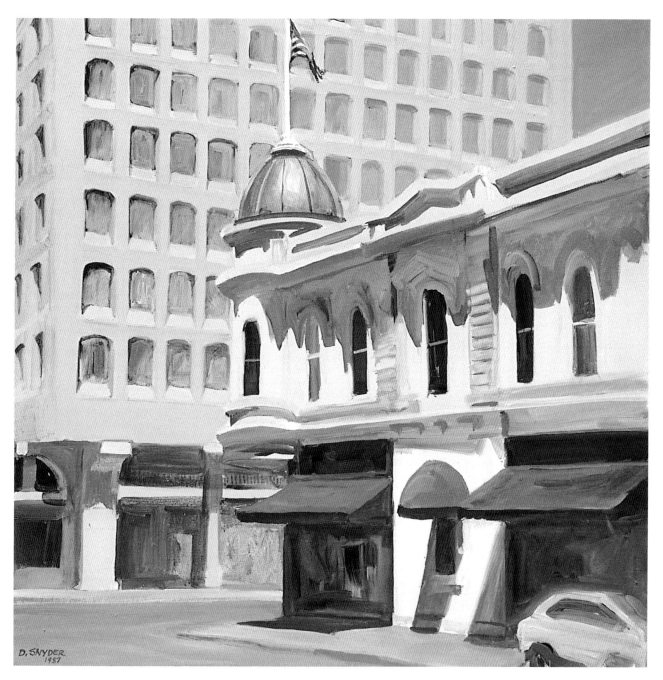

Dale Snyder
CORNER OF SECOND STREET
Acrylic on canvas, 42 x 45" (106.7 x 114.3 cm)
Collection of Janet and Christopher Schink

The purpose of Snyder's painting is not simply to describe in architectural detail an old domed building, but rather to capture the play of light and shadow on it. The artist has skillfully eliminated or subdued any distracting element, detail, or color in order to emphasize the color-filled shadow patterns as well as the reflective surface color of the golden dome.

Aerial Perspective As landscape painting developed over the centuries, artists became increasingly interested in the effects of *aerial perspective* on color: the modifying of the local colors of distant elements in a composition to suggest the veiling effect of the atmosphere. In the 18th and 19th centuries, European and American painters created impressive panoramic views, often with a bluish or neutrally colored mountain range in the distance—a now-familiar image with a convincing illusion of deep space.

Arguably, most contemporary painters are more interested in employing color to suggest shallow or flat pictorial space and employ aerial perspective more rarely. Still, there are some landscape painters to whom this technique in the use of perceptual color is useful. This subject is touched on again when we look at pictorial space and "receding" color (see page 66).

Atmospheric Color Romantic landscape painters of the 19th century often depicted wet atmospheric conditions such as rain, fog, and snow to create mood and to convey the dramatic forces of nature. Contemporary painters, usually in a more abstract way, continue to use this approach, altering and modifying local colors in order to capture and even give prominence to atmospheric effects.

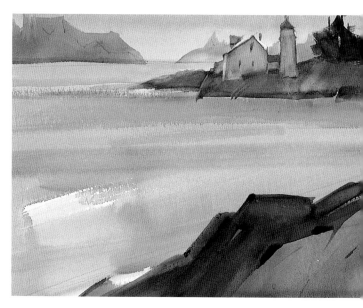

Aerial perspective: Here, the local colors of distant objects are altered—made cooler, more neutral, and narrower in value range—to suggest the effect of atmospheric vapor. As a result, my pictorial space is deepened.

Warren Taylor
VIEW
Watercolor on paper, 18 x 28" (45.7 x 71cm)

Even for contemporary realists, capturing the illusion of deep space is rarely a major interest. However, Taylor exaggerates aerial perspective, radically lightening and neutralizing the distant elements to give this imaginative still life an almost surrealistic landscape effect.

Atmospheric color: Local color is altered to capture the effects of rain, fog, or snow. My white lighthouse now looks gray in this foggy scene.

Judi Betts
MOURNING MIST
Watercolor on paper, 22 x 30" (55.9 x 76.2 cm)
Private collection

Judi Betts's intent in this painting was not merely to report visual facts but to expressively capture the effects of mist. In a carefully orchestrated arrangement of values and shapes, she has altered local color to create a mood. Note the almost total muting of the greens in the shrubbery.

Conceptual Color

Historically, painters (even those working in a fairly naturalistic style) have applied formal color schemes to their works instead of accurately reproducing the colors they perceive. Choosing their colors on the basis of harmonic relationships or color conventions, they have based their work on their knowledge of color or their ideas and feelings about a subject as much as (or more than) on visual reality. A full discussion of the conceptual approaches you might use can be found in Chapter 4, "Approaches to Color," but we'll start with a brief introduction to the fundamentals:

- Value relationships

- Color relationships

- Intensity relationships

- Symbolic associations

- Emotional content

Value Relationships Painters taking a "Tonalist" approach (discussed on pages 117–119) organize their paintings almost entirely around shifts in value. They may depart greatly from local color, or use color only minimally, electing to compose with neutrals and grays.

The results often suggest a somber mood, which many contemporary painters prefer.

Emphasizing contrasts in value and slight changes in color temperature can create a convincing illusion of form and space, as the next lighthouse illustrations show.

Value relationships: Here, the local colors of the scene are altered or ignored to create a color harmony. The composition is built up from the lights and the mid-range values of the yellow-browns; contrast is provided by the dark gray of the ocean.

Christopher Schink
STRING QUARTET
Watercolor on paper, 26 x 40" (66 x 101.6 cm)
Courtesy of Harbor Square Gallery, Camden, Maine

To create a classical-music feeling—quieter than I usually evoke in my jazz-inspired paintings—I limited the range of colors and their intensities in this painting and composed it almost entirely from light and dark elements —the differences in values.

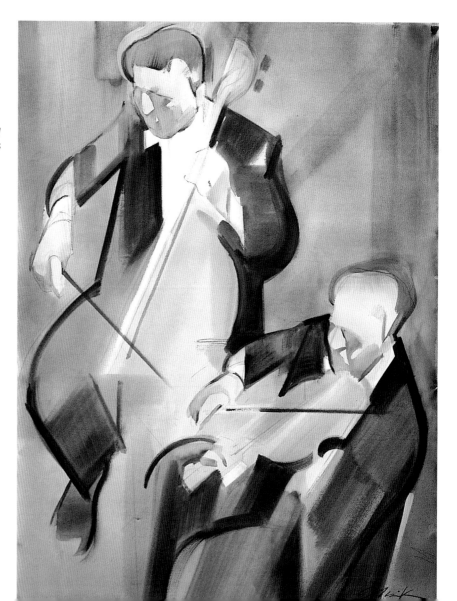

Color Relationships Here, too, your color scheme may have little or nothing to do with the local colors of your subject (if you have a subject). For example, you may be attracted to a single color, or to the interplay of two—say, a red terracotta roof against a twilight blue sky, or a red-headed child dressed in a bright blue coat. To emphasize the two colors, you will inevitably alter all the other colors in your painting. Thus, the relationship of red and blue becomes the basis of your overall color scheme.

Color relationships: Local color is altered or ignored to create an interplay of colors. Here, the harmony of yellow, pink, and orange is the basis of the design, not the white of the subject.

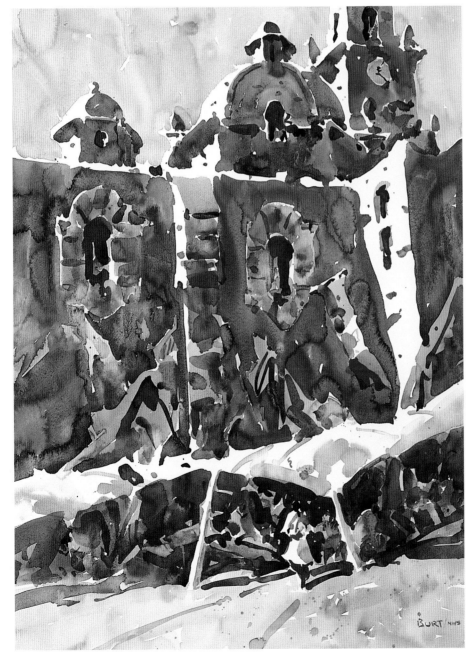

Dan Burt
Mexico Tipico II
Watercolor on paper, 30 x 22"
(76.2 x 55.9 cm)

The artist's palette here has little to do with the local colors of his traditional landscape subject. Note the unrealistic green on the church dome and the alternation of greens and browns throughout this composition. The interplay of color is vibrant.

Intensity Relationships Just as some painters prefer to work almost entirely with value or color relationships, others focus on changes in intensity. By organizing your painting around alternations of neutrals and intense colors, you can create a different mood in your painting from that which an adherence to local colors would produce.

Intensity relationships: Local color is altered or ignored to create a composition based on differences in color intensity. Here, the normally white subject is neutralized and intense blue-green and yellow are contrasted with it.

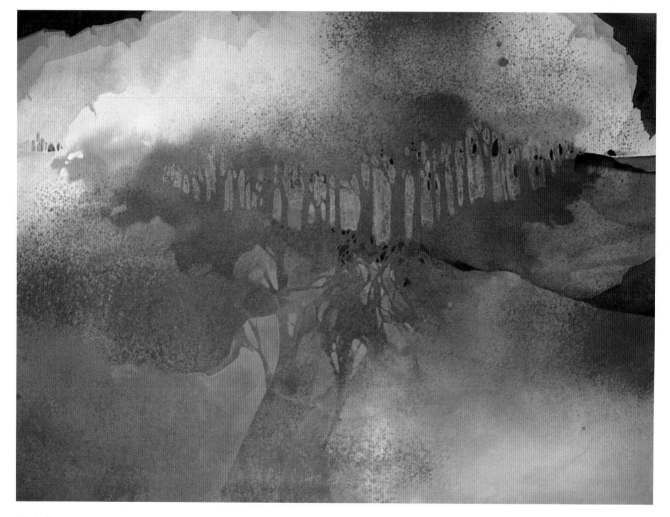

Linda Kemp
THROUGH THIS DOOR II
Watercolor on paper, 22 x 30" (55.9 x 76.2 cm)
Private collection

Canadian artist Kemp has avoided any reference to local color in this semi-abstract painting. Instead, she has taken an approach based on differences in color intensity and temperature. Intense blue contrasts with muted tints and shades, and cool contrasts with warm to create this evocative and lyrical work.

Symbolic Associations We all agree that red means stop and green means go—when we see a traffic light. Beyond that, the symbolic significance of colors is not so predictable. Although you may associate white with purity or red with royalty, your viewer's response may be very different, or perhaps indifferent.

Flat, bright, pure colors remind us today of commercial advertising as much as anything. The Pop Art movement's artists—Jasper Johns, Andy Warhol, James Rosenquist, and others—used these elements to create ironic paintings of familiar commercial products. With time, their commercial references have lost some of their significance. However, you may base your paintings on colors that are personally symbolic for you. If orange has a special significance to you, then whether it has broad cultural meaning is unimportant, for you really derive your ideas and inspiration by looking inward rather than outward.

Elizabeth Yarosz
RELUCTANT HOMESTEADER
Watercolor on paper, 40 x 60"
(101.6 x 152.4 cm)

Yarosz's paintings often have a surreal quality, juxtaposing seemingly incongruous images. Here, she has rendered her figure in traditional colors and introduced overlapping and underlying areas of flat, pure color. The effect is startling and engaging.

Emotional Content Psychologists have suggested that we all have common reactions to certain colors. To most of us, blue feels quiet, red powerful, orange exciting. You can choose the colors for your painting purely on the basis of your emotional response to your subject or idea. You can allow yourself to be guided either wholly or selectively by instinct. However, you don't have to define each color if you take the emotional approach—you can just feel your way. Many of the painters included in this book begin their paintings with just such an approach.

Emotional color: Here, local color is ignored and color choices are based entirely on an emotional response to the subject.

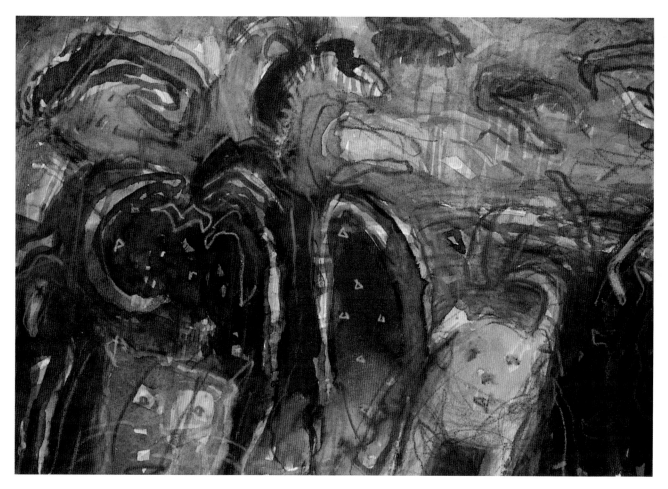

Kathleen Kuchar
NOLDE'S DOG
Watercolor on paper, 9¾ x 14"
(24.7 x 35.6 cm)

Kuchar's color choices are based on an emotional response. Her painting neither depicts effects of light or atmosphere, nor relies on a preconceived color scheme. She takes an entirely subjective approach to color—an expressionistic statement.

PROBLEMS AND PRACTICAL CONSIDERATIONS

Problem: Losing your direction

Paintings go awry when you stray from the reason you began the work, from what initially inspired you, be it the color quality or feeling you wanted to convey. This loss of direction and concentration is one of the biggest problems inexperienced painters have. They forget or lose sight of what inspired them and, instead, begin to record (usually with great accuracy) only what they see. For example, you may set out to capture the vivid colors of fall foliage and end up spending most of your time rendering the rust on an old bucket in the foreground.

The solution is to define your goal as well as you can in specific words and phrases and then, in practice, to stick to your story and tell it clearly. Writing down in your sketchbook the impulse that inspired you—be it the cool of a fall day, a golden oak juxtaposed with a dark evergreen, or your personal response to the change of season—and continually referring to it will help you decide whether each color decision you make will add to or detract from your original expressive intent. Be as single-minded as you can.

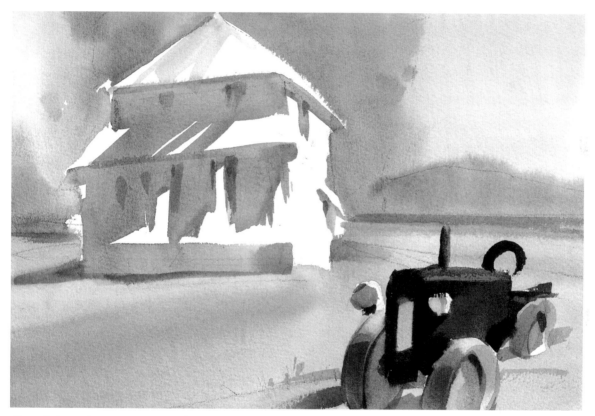

After painting an hour or two, you may forget what originally inspired you and find yourself working on some peripheral element that actually detracts from your expressive intent. Here, I started by trying to capture the colorful shadow on a white house and ended up doing a portrait of a red tractor. I lost my direction.

Problem: Too many ideas

Another common problem for beginners is trying to say too many things in one painting: "It was a cool, fall day, and the wind blew frothy white waves in the blue-gray water as colorful fishing boats in contrast with the moss-covered pier picked up the colors of the waterside restaurants with their cheery multicolored umbrellas, while overhead the heavy gray clouds of an impending storm filled me with alarm." You could get a week's worth of painting from that one sentence alone. Maybe two weeks' worth.

The solution, if you've done paintings that look the way that long sentence sounds, is to be selective. Limit the elements and color relationships in a painting to those that most strongly reinforce your primary interest. If you feel that you have many things to say about a subject, then plan a series of pictures that will cover them all, deliberately and one at a time—a tactic used by many masters past and present. You may be ambitious, but always strive to say what you have to say clearly, simply, and sincerely.

3 PERCEPTION, LIGHT, AND COLOR

There is no blue without yellow and without orange.

VINCENT VAN GOGH

Graphically recording something seen or experienced has inspired artists since they first painted images on the walls of caves. As stated in the preceding chapter, many artists still take a primarily perceptual approach to color—contrasting values and arranging intensities to capture a quality of light, a particular relationship of local colors, or an effect of atmosphere they have observed. In this chapter I briefly describe how our eyes and mind perceive color. I also show how we can replicate with paint the colors and particular lighting conditions we have perceived.

When we first started painting, most of us wanted to produce something that looked real, that matched with great accuracy what we saw. Optical accuracy was what most impressed family and neighbors and convinced them that we had talent. To some people, realistic representation will always be what painting is about. Yet, for most of us, the camera has changed that. With the advent of photography, the impact of exact realism in art greatly diminished. Now, most contemporary painters have abandoned optical accuracy as a primary objective. The role of painting has changed and become more subjective, even nonobjective.

Even so, understanding how we perceive the effects of light and color and how we can reproduce them in a painting, whether realistic or abstract, is essential to using color in a more personal and expressive way.

Visual perception is a complicated process and, despite ongoing scientific research, it is still not well understood. Vision actually occurs in the mind, not in the eye, and perception is as much psychological as physical: The retina receives light sensations and converts them into energy impulses that are carried to the brain; the mind, translating these impulses into an image, then responds to the visual features of the image. If it is a painted image, whether its forms are realistic or abstract, recognizable or unrecognizable, the mind associates these features with past visual experiences. If you do a painting in light, bright colors with a few darks, it will seem sunny, whether or not we recognize any objects in it.

How this knowledge will translate into a painting approach for you is the subject of the following pages.

SIMULTANEOUS CONTRAST

"The colors in my painting seem so weak and faded, and yours seem so vivid and strong," I've heard students say. "Where do you buy your paints?" If only it were that simple: buying the right paints and applying them with a magic brush. Much as they would like to believe otherwise, most of these students have the right colors and the right brushes; what they lack (so far) is an understanding of how these colors will appear when viewed in the *context* of their paintings.

Our perception of a color—our judgment of its value, or temperature, or intensity—is affected by what surrounds that color. Our perception of the surrounding color, too, is simultaneously affected. (Consider the example of color context illustrated here.) Every great colorist since Leonardo da Vinci has recognized and compensated for this phenomenon. But it was not until the early 19th century that it was scientifically described. In the 1820s, a French chemist, Michel-Eugène Chevreul, was hired to explain why the appearance of brightly colored threads changed when woven into tapestries. He published his discoveries in 1839 in a treatise, *The Principles of Harmony and Contrast of Colors and Their Applications to the Arts,* in which he explained the principle of *simultaneous contrast.*

No study of color has had a greater influence on painting than Chevreul's. He accurately described how we perceive color. Claude Monet and his Impressionist circle were deeply influenced by Chevreul's book. Paul Cézanne, Vincent van Gogh, Paul Gauguin, and Pierre Bonnard also are known to have understood the implications of Chevreul's ideas; so did the Americans John Singer Sargent and Winslow Homer.

The Impressionists created and exploited the interaction of colors on their canvases. They typically painted with small strokes of color that they called "touches" in complementary or near-complementary combinations (see pages 115–116). Georges Seurat, famously, read but misunderstood Chevreul's theory and created his Pointillist style. For example, according to Seurat, a jumble of small color dots of yellow and blue will optically mix as green and look more vibrant than a pure green painted in a solid block on a canvas. But his paintings often proved just the opposite: When he juxtaposed very small dots of color, the resulting optical mixture lost intensity and even appeared muted with gray.

Fortunately, practically every painter since has understood and correctly applied the principle of simultaneous contrast to create color interaction.

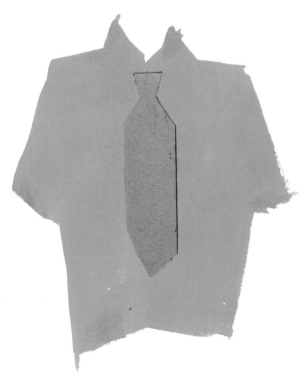 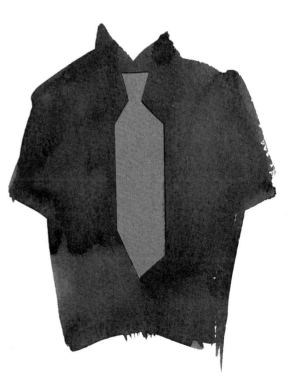

Context affects perception: My favorite green necktie, when I wear it with my green shirt, will look different from when I wear it with my magenta shirt. Our perception of the tie's value and intensity is affected by what color surrounds it. Simultaneously, the shirt's appearance is affected, too.

The Principle

Our judgment of a color is affected, sometimes subtly, sometimes strikingly, by the color of the area adjacent to it. This relativity in a color's appearance is the result of the complicated way our eyes and mind work. In the inner eye, the retina, light strikes photosensitive tissue made up of cells called *receptors*. When an area in the retina is stimulated by sensations of a strong dark, receptors that are unaffected are more sensitive to the opposite sensation, light, and so the adjoining areas appear lighter. When receptors are stimulated by sensations of a strong color—say, a bright red—the unaffected receptors are more sensitive to the *complement* of that sensation, green, and so the adjoining areas seem greener. Moreover, when we see an area of intense color, the adjoining areas seem more neutral. These are the workings of simultaneous contrast, by which the appearance of a color depends upon its relationship to other colors.

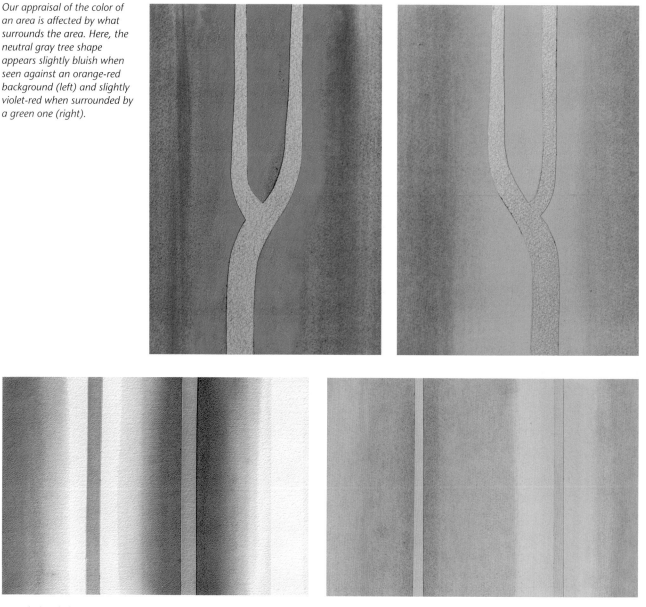

Our appraisal of the color of an area is affected by what surrounds the area. Here, the neutral gray tree shape appears slightly bluish when seen against an orange-red background (left) and slightly violet-red when surrounded by a green one (right).

How dark or light an area appears is also influenced by what surrounds it. These two gray stripes are identical in value but appear very different to our eye because of their contrasting backgrounds.

Here, the gray-green stripe, when viewed against a perfectly neutral background, seems fairly intense. But against a bright yellow-green background the same gray-green seems muted, almost grayed down.

Rob Anglin
DANISH GARDEN
Watercolor on paper, 15 x 22"
(38.1 x 55.9 cm)

Although Anglin put a predominance of neutrals and muted colors in this painting, he kept them from appearing dreary by constantly juxtaposing areas of complementary or near-complementary colors. Note how he "activated" his color by placing a red-orange next to blue-green and a red-violet next to a muted yellow.

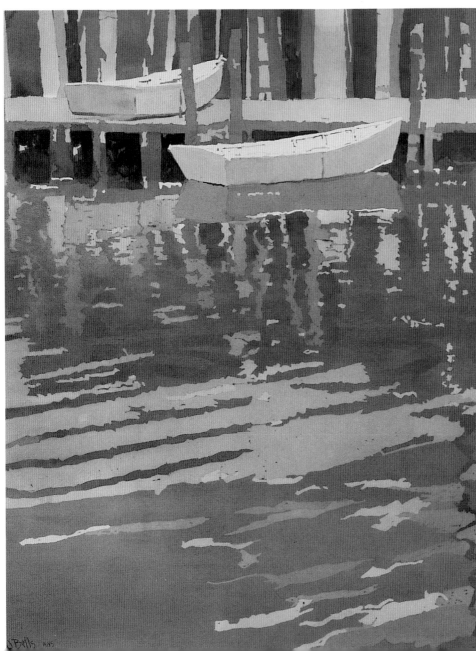

Judi Betts
RIPPLES
Watercolor on paper, 30 x 22"
(76.2 x 55.9 cm)

Betts creates subtle color interaction by opposing two complements—a tinted blue and muted orange—in this well-designed painting. Without the presence of its complement, blue, even the orange would seem uneventful. But when she relates the two, her painting takes on a quiet glow.

Because of the strong dark around it, the sailboat here appears lighter in value than the surrounding background, including the white at the bottom.

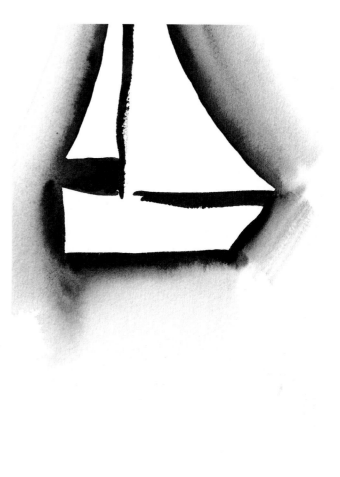

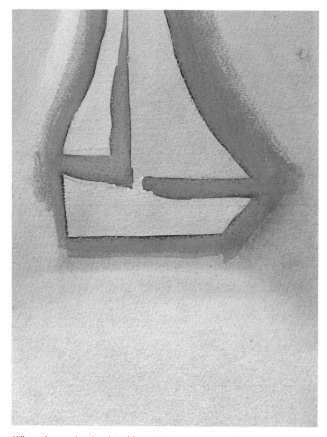

When the eye is stimulated by a strong sensation in one area, it becomes more sensitive to the complement in the adjoining area. Here, the gray sailboat is bordered by a violet-red, so it appears to be a slightly greenish yellow, the complement of violet-red.

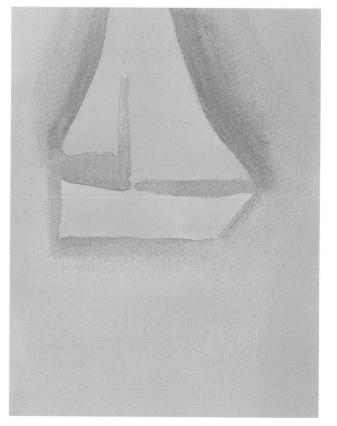

Because of the gray bordering it, the yellow-green in the sailboat appears stronger in intensity than the yellow-green background. Because of simultaneous contrast, the boat's gray border appears slightly violet.

You can't judge a color out of context. How it looks on your palette is not the way it will look in your painting. And its appearance in your painting will change, and continue to change, as you add other colors and values in progressing through your work. Initial washes that seemed dark on your white paper will seem to lighten when darker hues are introduced; dull colors will seem to brighten; nothing will look the same.

As you become more experienced, you will anticipate these changes and exploit them to make the color in your painting more lively and expressive. This development marks an important advance in the technique of any painter.

Your knowledge of simultaneous contrast will contribute greatly to your use of color and its effects in the handling of light and shadow, which is our next topic.

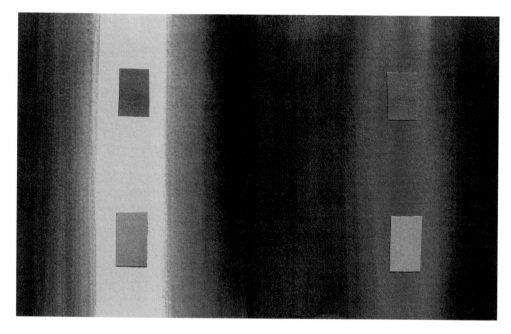

When receptors in the retina are stimulated by a color sensation, unaffected receptors are more sensitive to the complement of that sensation. Here, the muted magenta rectangle appears more intense when viewed against its complement, yellow-green, than against red. The muted green rectangle appears more intense when seen against its complement, red, than against yellow-green.

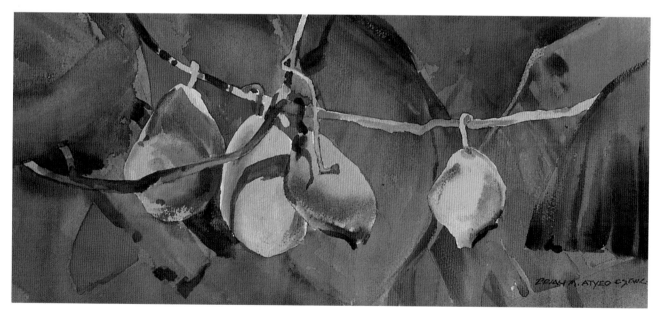

Brian Atyeo
HAWAIIAN PUNCH
Watercolor on paper, 10 x 22" (25.4 x 55.9 cm)

Exploiting the effects of simultaneous contrast, Atyeo plays small areas of bluish color—violet, blue, and blue-green—against orange, the complement of blue. Even though the orange is muted, this sets up a strong interaction between the colors.

Light and Shadow

The Impressionists, informed by the findings of Chevreul, began not just to compensate for the effects of simultaneous contrast but to emphasize and even exaggerate those effects. They were able to create more vibrant illusions of light and to make their shadow areas glow with color.

Leonardo, as we have seen, observed and illustrated the effects on the figure of light and dark. Titian, Caravaggio, and Rembrandt then exaggerated these effects. But Claude Monet produced a series of Impressionist paintings whose only real subject was the interplay of color in light and shadow.

Monet recorded the changing light conditions on a lily pond, on the facade of Rouen Cathedral, on haystacks, and on other subjects. In these important works, Monet exploited the effect of simultaneous contrast, using the hue of a light source to determine the hue of his shadows. Thus, when a haystack was illuminated by the yellowish sunlight of early morning, Monet painted its shadow with the complement of yellow, which is violet.

Simultaneous contrast is a fact of our visual perception. Turned into a principle of painting, it can contribute greatly to your skill in using color. You can observe how simultaneous contrast affects our perception of light and shadow and then exploit the same color interactions Monet did. Study the following illustrations, in which I have used a simple design in flat, colored shapes that suggest a typical landscape motif.

Using Reflected Light Shadows in strong illumination do not appear to have uniform value or color because of two factors: reflected light and the effect of simultaneous contrast.

In what is sometimes called *color bounce,* the interior of a shadow will be lightened and colored by light reflected from another surface. The color of the reflected light in a shadow is, of course, the color of the reflecting surface. In an outdoor scene, the area within open shadows will often be lightened and cooled by the blue of the sky. But keep in mind an important point: No reflected light is strong enough to influence the color of an area illuminated *directly* by sunlight.

A rule of thumb: Shadows that are cast *by* an object will appear darker than the shadow *on* an object. And, because of simultaneous contrast, cast shadows tend to be cooler (and darker) at their edges, where they immediately abut warmer (and lighter) color.

We perceive a shadow as being the complement of the light source. Sunlight is warm, so by choosing complements—a yellow tint for the illuminated areas of the building and a violet for the shadows— I am exploiting simultaneous contrast to heighten the vibrancy of my image.

Because of simultaneous contrast, if the illumination of the building is reddish, the shadows will appear greenish. To paint the motif, red was my choice of hue for my light source, so for the shadows I used its complement, green.

Here I have adapted the warm light and complementary shadows of the earlier illustration. Now I have washed a reflection of the blue sky onto the roof and infused a "color bounce" of my yellowish light from the ground into the building's violet shadows. Capturing reflecting colors such as these can further enliven your use of color.

This time the color of the reflecting surface—the bright orange of the surrounding field—bounces onto the building's violet-shadowed side. The roof, facing upward, reflects the blue of the sky. These may seem to be colorful devices, but they represent a fact of our visual perception.

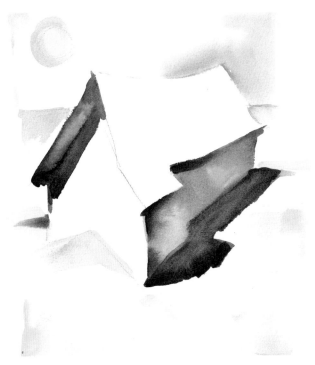

When illumination becomes so strong as to create glare, the local color of objects in light will appear washed out and cast shadows can appear almost black. Here, I convey these effects by whitening my building but employing vibrant color as reflections into its shadowed side.

Shadow color is affected by atmosphere. To capture the effect of an overcast or misty day, I give an overall violet cast to the light source. My shadows are less pronounced because of the low illumination. Because of simultaneous contrast, nearby objects' shadows appear warmer in this light, so in the shadows here I have moved toward yellow, the complement of violet.

Enhancing Color by Reducing Value Contrasts

The Impressionists, with their vivid use of simultaneous contrast, inspired succeeding painters to take an entirely new approach to the use of color. Post-Impressionists such as van Gogh, Gauguin, Cézanne, and Bonnard became interested in the interaction of color without regard to their perceptions. Their approach took painting further in the evolution toward the conceptual, subjective color we associate with Matisse. Van Gogh and Gauguin explored simultaneous contrast to heighten the emotional and symbolic content of their paintings. In Cézanne and Bonnard, local color was often changed freely as these artists employed the interaction of color almost as an end in itself. Bonnard's canvases, in particular, almost seem to vibrate with color.

This simple design in flat colors makes use of simultaneous contrast in only the most basic way: The red wharf contrasts with the complementary green water.

Here, I've explored the preceding design's color effects further. To the basic red–green interaction I've added the interplay of two more colors—the oranges blended into the wharf and the blue of the sky. Note also the subtle red–green interplay on the boat. There is a gain in vibrancy here because of simultaneous contrast.

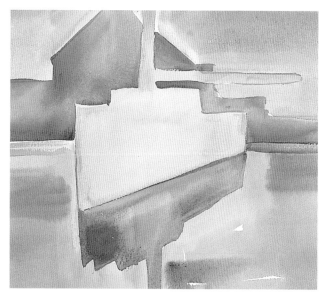

This time I've reduced contrasts in value to emphasize the effects of complements. The picture employs only light to mid-range values; there are no real darks. When strong light–dark contrasts are present, the eye's sensitivity to color nuances is weakened. Thus, you can achieve a stronger interaction of colors when you keep value contrasts to a minimum.

Here, I reduce value contrasts by limiting my predominantly light colors to edges. This is done using the technique of Cézanne, who often ignored the local colors of his subjects and concentrated instead on subtle, warm–cool contrasts along the boundaries of objects. Note the prow of the boat, defined only with yellow and violet (two complements —the one warm, the other cool). The colors enhance each other, making the picture delicate and lively at the same time.

Seeking ways to increase vibrancy, these artists discovered that when the eye sees *strong value contrasts,* its sensitivity to subtle nuances in color is *weakened.* They therefore made a practice of reducing contrasts in value so that they could better explore subtleties of color.

In the following illustrations, I survey a number of color-enhancing techniques that take advantage of this discovery.

1

2

3

4

Here, I illustrate some basic advances toward a more color-enhanced picture. You may wish to duplicate this exercise with your own motif.

1. Against the intense yellow-green bowl, the muted green apple seems cold, gray, and dark. This combination scarcely exploits color effects at all.

2. Against a light red, the same apple becomes more intense and greener-looking—a simple contrast of two complements.

3. Against the dark violet, the apple appears lighter, warmer, and more like the complement of violet, yellow. The value contrast in this case is strong.

4. Finally, the appearance of the same apple is enhanced by lowering value contrasts and shifting the bowl color from red to violet to orange. Light–dark contrasts have been made minimal to take advantage of the interplay of colors.

Harold Gregor
ILLINOIS FLATSCAPE #42
Acrylic on canvas, 60 x 82" (152.4 x 208.3 cm)

The artist uses a great many complements to create maximum color interaction in this large acrylic painting. You can often enhance color interaction in a transparent watercolor by adding small touches of complementary color with acrylic, gouache, pastel, or crayon.

VOLUME AND COLOR

When painters during the Renaissance first discovered how to model objects with lights and darks to make them appear three-dimensional, their paintings reportedly amazed viewers. The artistic illusion of three-dimensionality achieved through modeling with lights and darks remained a convention of Western painting up to the mid-19th century and the advent of photography. Until then, paintings were supposed to look real; the objects in them were to have volume and appear "rounded." With Impressionism and Post-Impressionism came flat design, inspired by an interest in Japanese prints. Matisse created works that radically emphasized flat patterns of color and shape. Thus, form began to flatten and became shallower with each succeeding art movement. By 1920, two-dimensionality had become the rule in many painting movements.

Contemporary artists work in a variety of styles which largely *avoid* the illusion of volumes in space. Indeed, to fashion a painting with the goal of creating an *illusion* is rarely a goal of present-day painters. Most of us today don't react with much amazement to a painting of an apple that looks round, and fewer of us take interest in striving for that effect in our work.

Still, you need to know *how* to make things look round, and, if you wish, make things look flat. Like so many of the effects described in this book, the illusion of two- or three-dimensionality depends on your control of value contrasts, color temperature, and intensities.

Volume and Color Values

In modeling an object, you give it the appearance of having volume by rendering it in terms of light and shadow. This is probably one of the first things you learned in art class. Our rendering of the forms of objects—their volume and three-dimensionality—is based on the light and dark patterns we observe on them. Here are the basics of modeling technique:

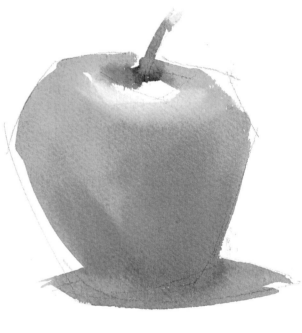

- The greater the value range on an object, the more three-dimensional it will appear.

- Conversely, when values on an object are fairly narrow in range, it will appear flat, even when rendered in complementary hues.

- The local color on an object's illuminated side is light in value. (It is also warmer, moving toward yellow.)

- The local color on an object's shadowed side is darker and less intense. (It is also cooler, moving toward violet.)

Shifts of color on an object can enhance the illusion of volume, as we'll see below, but they are less important than strong contrasts in value.

We create the illusion of three-dimensionality primarily by contrasts in value: The apple at right, painted with a full range of lights and darks, seems rounder and more real than the apple above it, painted in narrow value range.

Christopher Schink
DANCE MASTER
Watercolor on paper,
22 x 26" (55.9 x 66 cm)
Private collection

*In this straightforward figure
painting, I have employed a full
range of values to model the
form and make it appear three-
dimensional. The highlights are
white or off-white, and the darks
go almost to black. The figure
looks convincingly round and real.*

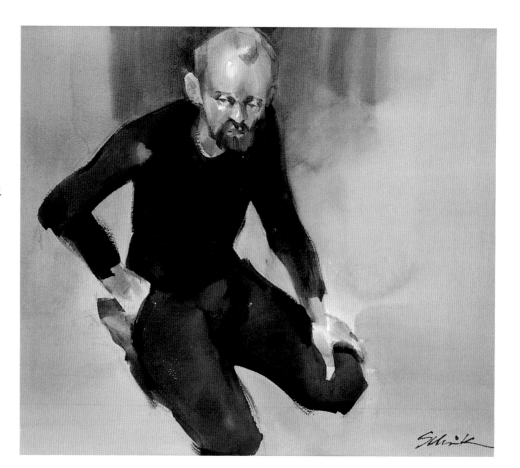

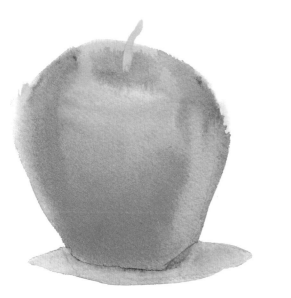

*You can enhance the illusion of an object's three-dimensionality by shifts of color in your
modeling, but you still need shifts in value to make it convincing. The apple on the right,
painted in almost neutral color, may look less appealing than the apple on the left, but it
appears rounder nonetheless.*

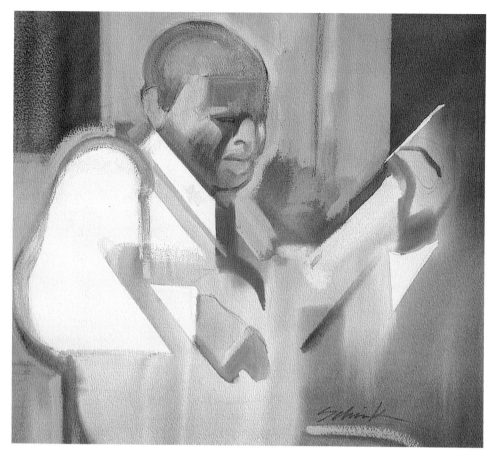

Christopher Schink

GRAY GUITAR BLUES
Watercolor and acrylic on paper,
24 x 26" (61 x 66 cm)

Here, my objective was to reduce the figure's rounded quality to add to the harmony of the overall design. (Remember, you have a choice.) I narrowed my light-to-dark range (it goes from off-white to middle values), and consequently the form in this painting appears flatter than in Dance Master (opposite).

On both apples I have employed a full range of color. The right-hand apple has strong value shifts added to it. On both, the illuminated side shifts slightly toward yellow; here it is warmer. The shadowed side shifts toward violet; here it is cooler. Warm–cool shifts strengthen the illusion of three-dimensionality.

Volume and Color Range

The impression of three-dimensionality that you create with lights and darks is reinforced when you employ a full range of color, because of the changes in color temperatures. That is, with varying mixtures of red, yellow, and blue, you can most effectively model the form of an object, warming it where it *advances,* cooling it where it *recedes.* As we shall see later in considering pictorial space, warm colors tend to advance toward, and cool colors recede from, the viewer—a phenomenon you can exploit in modeling objects to appear rounder or flatter, depending upon your aims. (The principle of "receding" color is examined more fully on page 66.)

As noted previously, we can enhance the illusion of an object's form by showing changes in color temperature that occur in an object's lit and shadowed parts; you mix warmer color for its illuminated side and cooler color for its shadowed side. But there are further interesting subtleties to explore in using a range of colors in modeling.

For instance, on a smooth-surfaced object we can often introduce a cool note by adding blue as a reflection of the sky. Assume that you have made the illuminated area sunlit and warm. Where the surface begins to turn away from the light source, you create the gradual start of the shadowed side. This is a "half-light" that should appear particularly cool to exploit the natural effect of simultaneous contrast. Compared to the lighted side, the core of the full shadow should appear cool, but it will also appear slightly *warmer* than the half-light. You can shift the temperature of the shadow area, however, by adding reflected light—cooling and lightening it where the object is able to reflect the sky. You also can warm and lighten it with a reflection from a warm-colored surface—a color bounce. In the series of illustrations below I show how you can add both warm and cool notes to shadow.

This natural progression of warm to cool allows you to create volume using a fairly wide color range. To make an object appear just as richly colored and yet flat, you would need to alter this progression.

On a smooth-surfaced object—for example, a wet rock, a billiard ball, or a polished table—we often see a cool highlight representing a reflection of the sky. Note the faint blue area on the upper surface of this sphere.

Where the sphere is illuminated by sunlight I have given it a slightly yellow cast. Surrounding that area, in the half-light where the surface begins to turn away from the light source, I added a cool gradation to exploit the natural effect of simultaneous contrast.

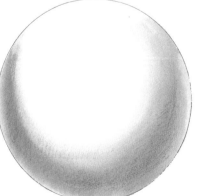

We see the core of a full shadow (again because of simultaneous contrast) as warmer than the half-light. To take advantage of this fact, I washed in a violet shadow and then added touches of red-violet (using pastel) for the shadow's core.

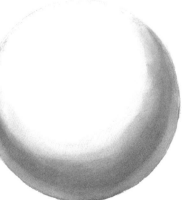

Reflected light can be cool or warm—or both. Where the fully shadowed area faces upward it would reflect the sky, so I added a cool blue highlight. Where it faces downward, it is illuminated by warm, reflected sunlight.

Volume and Color Intensity

We see the local color of an object at its greatest intensity where it is strongly illuminated (unless there is a glare); in its shadowed area, the local color appears more neutral. Beginners invariably paint things in this logical way, making their shadows too gray and relying mostly on the change of intensity to make things seem three-dimensional.

An object can be made to appear flatter if you reverse this quite logical order, making the shadowed side of an object more intense and the lighted side grayer or more neutral. But the effect will be disturbing to the eye. You can create a somewhat flat effect, however, by making both the lighted and shaded sides equal in color intensity.

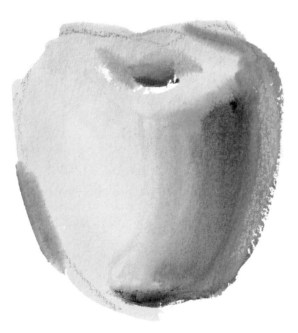

Volume and color intensity: I used the most intense color for the green apple's lighted side and more neutral green for the shadowed side (top left). Making the lighted side more neutral and the shadowed side more intense, as I've done with the top right apple, will flatten the form, but the effect is unnatural. Making the lighted side and shaded side equally intense (bottom) slightly flattens the form in a more attractive way.

Light Direction

An artist can always choose the direction of the light that illuminates the objects in a painting. You can most effectively render the volume of objects when you show them strongly illuminated with light coming from the side. Since the Renaissance, realist painters have employed sidelighting because of the strong shadows that this type of illumination creates. With sidelighting you are able to emphasize contrasts between lights and darks—the value shifts between the lighted side and the shadowed side—on objects. Moreover, textures on objects can be emphasized.

Of course, creating volume will not always be your concern in your work; flatness, for instance, permits you to explore shape and pattern more fully. For a flat effect other choices in lighting are preferable; we'll examine these as well.

The Post-Impressionists seem to have simply avoided subjects lit from the side. They wanted to achieve the flat areas of color they admired in Japanese prints. They thus employed frontal lighting with its washing-out of shadows and consequent elimination of strong value contrasts.

To make an object appear flat, you could paint it as if it were lit from the front, with a narrow range of values or with the introduction of light values into the shadowed areas.

Asian artists have traditionally employed backlighting as well as frontal lighting. Backlighting creates poetic, flat-patterned designs. In backlighting, diverse objects blend together and their interior detail and three-dimensional form are lost in a silhouette or near-silhouette.

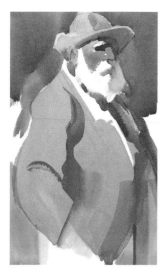

Sidelighting: You can most clearly depict form when it is illuminated from the side because of the contrast in value that it causes on an object. Here, my figure (looking like Claude Monet) is lighted directly from the left.

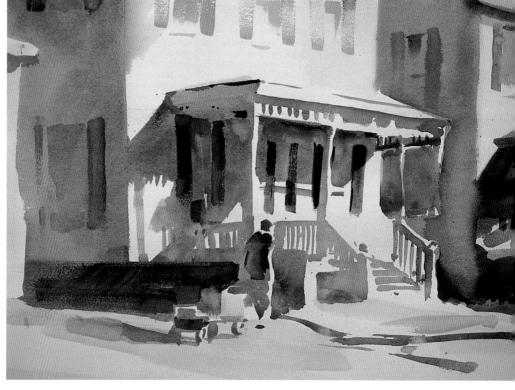

William (Skip) Lawrence
MORNING DELIVERY
Watercolor on paper, 26 x 29"
(66 x 73.6 cm)

Lawrence chose sidelighting for this fresh, direct watercolor. When objects are lit from the side, we can easily discern their form and texture. With this choice, however, strong light–dark contrasts result, and we are less able to explore subtle nuances of color.

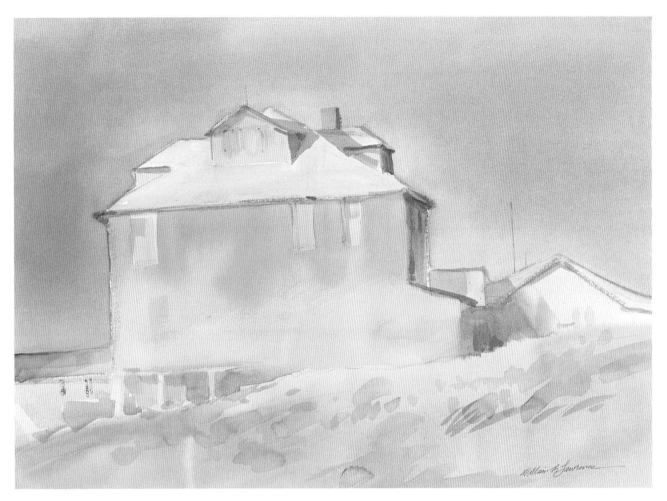

William (Skip) Lawrence
The Miller House
Watercolor on paper, 20 x 26"
(50.8 x 66 cm)

To reduce value contrast and emphasize color in flat shapes, Lawrence has painted his subject illuminated directly from the front. With no shadow evident to help us recognize its form, it appears flat. With frontal lighting and evenness in value, subtle differences in color can predominate.

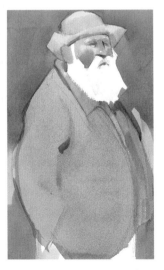

Frontal lighting: Illumination from the front of an object flattens its form and gives emphasis to its overall shape. Because of the frontal lighting here, we're less conscious of this figure's texture, but better able to see interior detail such as the facial features.

Backlighting: Lighting an object from behind means that its shadowed side faces the viewer. By doing so, you effectively flatten a form, diminish interior detail, and emphasize shape instead of volume. Now my figure appears in near-silhouette.

The Post-Impressionists, inspired by the flat color areas in Japanese prints, almost eliminated modeling and value contrasts altogether, as I have done here. Their interest was often in exploring the relationships between shapes.

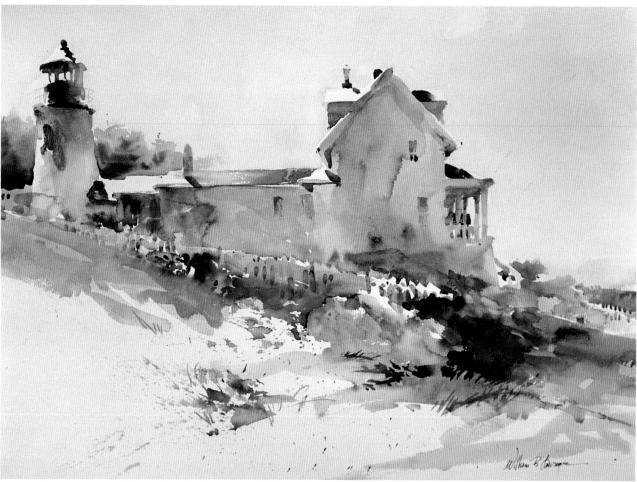

William (Skip) Lawrence
PEMAQUID LIGHT
Watercolor on paper, 20 x 26" (50.8 x 66 cm)

Here, Lawrence employs backlighting to unify his shapes. To heighten interest, Lawrence has emphasized the contour, or outer shape, of the building, which we see in near-silhouette.

Exploring Flattened Form

Frontal lighting and reduced value contrast are just two of the methods contemporary painters use to flatten form. Since Cézanne, artists have used flattening devices not only on their forms but in the surrounding spaces to make their work appear as two-dimensional and shallow in depth as possible. Pablo Picasso and Henri Matisse made regular use of a dark or light outline drawn around their figures to flatten their form, and this device is still used by contemporary painters.

If you vary color qualities such as temperature and intensity in an inconsistent way—rather than using them in a traditional, natural-looking way—you will flatten your forms. For example, when you make the color temperature in the shadowed area of an object as warm as (or warmer than) the color in the illuminated area, the object will appear flatter. Reversals in normal color intensity—rendering the shadows with more intense colors than the lighted areas—work similarly to reduce volume and depth.

Compare the following illustrations, in which I demonstrate a number of these flattening techniques after initially rendering my subject in a traditional way.

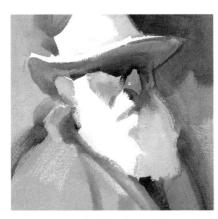

Here, I have rendered my figure's head using color temperatures and values in a consistent and natural-looking way.

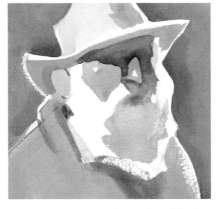

No part of the shadowed area of an object is as light as the light values on its illuminated side. But if you leave lights or whites in a shadowed area, as I've done here, the object will appear flatter, like a cut-out.

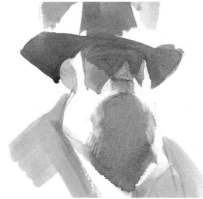

Contemporary painters who like to exploit value contrasts will employ passages of equal value on forms and in the surrounding space. This flattens both the form and the overall pictorial space. Here, I used the same white value on both sides of the beard and left a passage of white from the beard in the space around the hat.

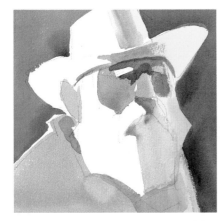

Inconsistent, or unnatural, temperature shifts on an object flatten its form. As the color in the shadowed area of an object warms up, the object appears flatter. Note here how I used yellows and oranges in the shadowed side of the figure. Making them intense also adds to the inconsistency—the reversal of the norm. (Since warm colors advance and cool colors recede—as explained later—this manipulation of color also makes the far side unnaturally advance, rather than recede.)

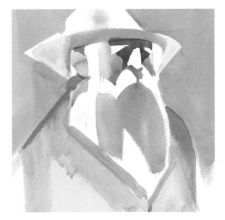

Evenness in color intensities across a form effectively flattens it. I used color that is roughly equal in intensity on both sides of the form. Thus it appears flattened—or even a bit concave (note the beard here!).

CONTROLLING PICTORIAL SPACE

In the history of painting, beginning with the earliest cave drawings, the artist's treatment of pictorial space evolved from flat and shallow to round and deep (in the Renaissance), and then back again to flat and shallow. Eventually, influenced by Cézanne's experiments in organizing and flattening space, Pablo Picasso and Georges Braque set the two-dimensional stage for the 20th century in their remarkable Cubist still lifes. They contracted space into an almost flat plane on which background and object vied for position. Then Matisse adapted their ideas to create works with totally flat patterns of color and shape. By the 1950s, Abstract Expressionism had made the two-dimensional surface a basic tenet of contemporary painting. Whichever treatment you choose, you will want to understand how color plays a role in pictorial space.

Color and Space

As we have learned, the term *aerial perspective* describes the way local color is modified when viewed at a distance through increasing amounts of water vapor—that is, the atmosphere (see page 38). To put it most simply, distant objects painted not their local color but in lighter, more neutral shades, especially in grays or blues, seem to *recede* into space.

If you've had any art training, you know it's not a very difficult trick to create the illusion of a great expanse with a distant bluish mountain range. But if you've studied art history, you also know that few works of art are based solely on this simple effect; with the exception of the great panoramic landscapes, most masterworks since the Renaissance have been contained within comparatively shallow pictorial space. Many contemporary painters have consciously *reversed* the effects of aerial perspective to maintain the flat quality of their picture surface.

I've illustrated below how aerial perspective is suggested in a painting and how you can employ, reverse, or ignore these effects.

Advancing and Receding Color As mentioned earlier, one phenomenon of color perception is that different colors seem to advance toward or recede from the viewer. Here are the basic ideas you need to remember:

- Warm colors appear to advance and cool colors appear to recede.

- Strong value contrasts appear to advance and slight value contrasts appear to recede.

- Intense colors appear to advance and neutral colors appear to recede.

There are some useful corollaries to these ideas: A textured area of color, for instance, will appear closer and more substantial than a perfectly smooth color, which will appear more distant and "aerial." Furthermore, regardless of the values or color you use, a shape will recede in pictorial space when clearly overlapped by another shape.

Now let's examine the technical implications of these ideas in the following illustrations.

Here, I've made the color of the closer building on the right warmer and more intense, and I've painted with a full range of values from pure white to deep darks. The color of the building in the middle distance, when viewed through the atmosphere, appears cooler and more neutral (the white of the roof appears slightly grayed), and it is modeled with less contrasting values. Finally, the golden color of the hills when viewed at great distance appears a cool middle-value gray and there is little or no value contrast in them.

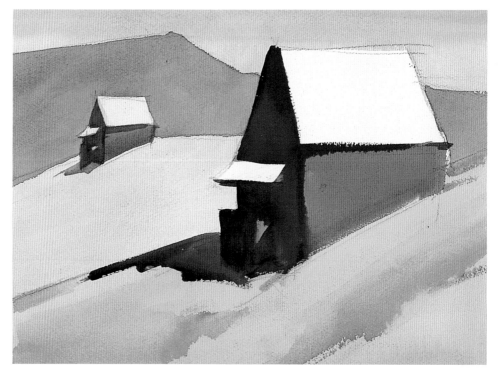

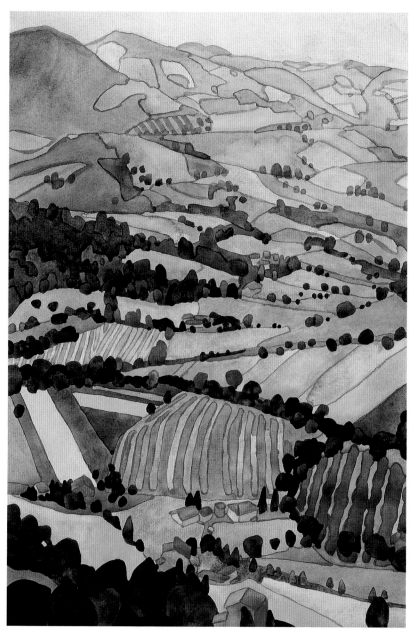

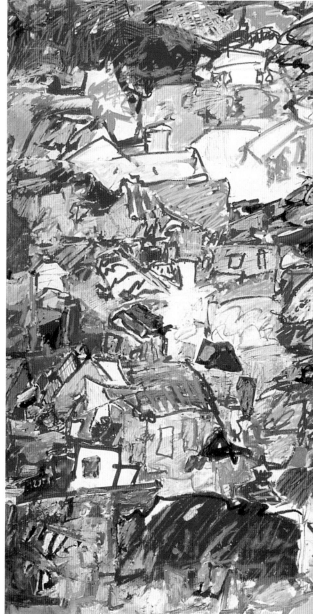

Carolyn Lord
BELVEDERE
Watercolor on paper, 22 x 15" (55.9 x 38.1 cm)

Artist Lord normally composes her images with flat color areas in a fairly shallow pictorial space, but here she uses aerial perspective to suggest a receding Italian landscape viewed from a hilltop. Note that her flat, stylized forms have few light-to-dark shifts within them. She has thus avoided straight, illustration-style painting and has produced instead a more personal and contemporary work.

Carol Tolin
VERMONT
Acrylic on paper, 37 x 24½" (94 x 61 cm)

Tolin avoids any reference to the effects of atmosphere in this landscape. With expressive brushwork and a repetition of color throughout, she has created an exciting work in which the terrain does not recede into space but goes straight up. Notice how different are the treatments of space in this painting and in Carolyn Lord's Belvedere.

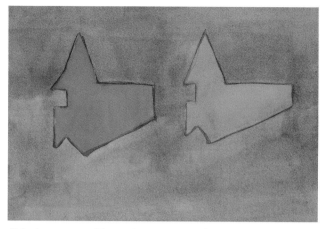

Color temperature: Warm colors appear to advance and cool colors to recede. Thus, the cool green shape on the right looks farther away than the red-orange one on the left.

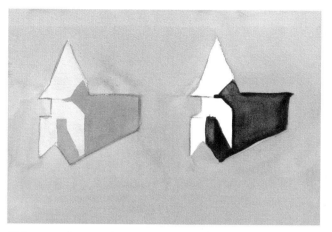

Value range: Strong value contrasts appear to advance and weak value contrasts to recede. This time, the shape on the right now appears closer to us because its white-next-to-black modeling is more contrastive than the all-gray modeling of the one on the left.

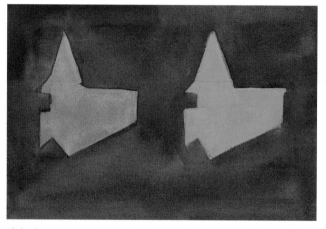

Color intensity: Intense color will appear to advance and neutral color to recede. The more intensely green shape thus appears closer to us than the muted one on the left.

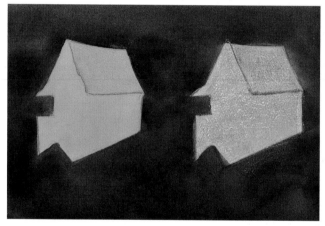

Texturing: A textured color will appear closer and more substantial than a perfectly smooth color. Thus, the shape on the left appears more distant and aerial than the rough-textured one on the right.

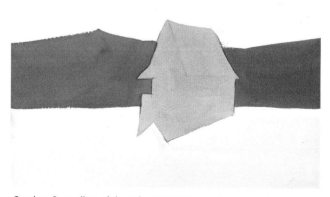

Overlap: Regardless of the value contrasts on a form, its color temperature, or its intensity, a shape that is clearly overlapped by another shape will appear "behind" it. Thus the mountain range, though painted in an advancing, bright red-orange, clearly seems more distant than the neutral house. But the key word is "clearly"; compare the next illustration.

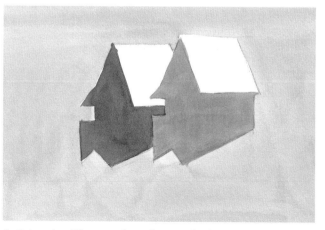

Partial overlap: When one shape does not clearly overlap another, the warmer, more intense shape will "push" forward slightly. Here, the two shapes appear to interlock as much as overlap. The advance of the red-orange color makes the left one "fight against" the overlap by the right one.

Brian Atyeo
SHORE LIGHT
Watercolor on paper, 22 x 30" (55.9 x 76.2 cm)
Collection of the artist

Atyeo uses aerial perspective and overlapping forms to create depth in this landscape. But ignoring local color (the dark greens of Northern Ontario) to a considerable degree, he relies on value contrasts (weaker in the background) and differing intensities (stronger in the foreground) to create pictorial space.

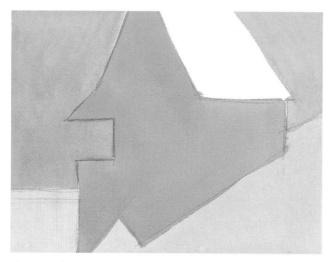

Reversing the natural order of color temperatures will flatten space. When the space around a shape is warm and the shape itself is cool, the advance of the warmer background will create a flatter design. To better observe this effect, view this design from a side angle.

Reversing the natural order of color intensities will also flatten space. This neutral shape is surrounded by more intense color, so it recedes and the space advances, creating a flatter design.

When values on a shape are alternated both on the shape and *in the space*, as they are here, the position of the shape in the surrounding space becomes ambiguous.

When the color temperatures within both the shape and the surrounding space are alternated, the shape's position in space becomes more vague. Here, blue-green and orange-yellow alternate in the shape and, in reverse order, in the space around it. The effect is spatial ambiguity.

Here, colors are repeated throughout the design and color temperatures alternate. The shape is alternately cool, then warm, when viewed against the alternating yellow-orange and violet of the surrounding space. When you do this, a feeling of "pushing and pulling" of space will result.

Henry Fukuhara
BLUE GREEN ORANGE
Watercolor collage on paper,
18 x 24" (45.7 x 61 cm)
Private collection

Although he suggests a cityscape with his calligraphic drawing, Fukuhara consciously avoids any reference to aerial perspective. The advancing and receding effects of color also contribute nothing to his design. He repeats large areas of pure color and strong value contrasts throughout so that the distant part of his landscape appears as close to us as the "front." A look at this painting upside down is instructive.

Charles Winebrenner
HEARTS
Mixed media on paper,
36 x 36" (91.4 x 91.4 cm)

Winebrenner repeatedly overlaps forms to create a sense of spatial ambiguity in this thoughtfully designed painting. By overlapping the intense yellow in the upper left corner with a white shape, he keeps it from advancing. Conversely, he keeps the dark, neutral shape in the center from receding by placing it "in front of" a light shape.

Figure and Ground Relationships

By now you recognize that the use of color in the treatment of pictorial space is important, especially in contemporary painting. Drawing upon many of the principles we have covered, in this section I illustrate some of the ways you can use value contrasts, advancing and receding color, and other qualities to control *spatial relationships*. In a painting, the illusion of space commonly depends upon the relationships you establish between the objects depicted. To survey a number of ways that pictorial space can be deepened or flattened, we will focus on the most elementary kind of relationship—that between figure and ground.

My demonstrations are based on a painting of a tap dancer I began in a watercolor seminar and had to leave unresolved when both my allotted hour and inspiration ran out. The basic design, done using transparent watercolor (with acrylic additions made later), is fairly simple—I wasn't about to try anything tricky in front of so many people—and really has only two elements: the

figure (the dancer) and the ground (the surrounding area against which it is seen). The figure's clear overlap of the verticals in the ground establishes its forward position.

Study my demonstrations to see how the range of values, color temperatures, and intensities in your treatment of figure and ground can be varied to affect spatial relationships. Here are some of the principles that I have applied:

- Repeating the color of the figure in the surrounding ground to flatten pictorial space.

- Using intense color and value contrasts in the figure but surrounding it with a neutral, light ground—thus avoiding deep pictorial space.

- Isolating the figure in deep pictorial space by severely darkening the ground.

- Painting the ground in intense and/or warm color to establish a close relationship between figure and ground.

- Repeating the values of the figure in the ground to give a consistency to both figure and ground—thus reducing the illusion of deep space.

- Alternating colors and color temperatures to closely relate figure and ground—thus flattening pictorial space.

- Alternating the interplay of light against dark in the figure and ground to closely relate them—thus reducing the illusion of deep space.

- Painting *across* the boundaries of figure and ground to create a vague, but animated, spatial relationship between the two.

- Alternating small areas of the same colors throughout the painting to create an ambiguous figure–ground relationship.

As you will see, I've frequently altered the two elements of figure and ground to reduce the illusion of pictorial space. You may wish to practice each one of these variations with a simple figure–ground study of your own.

I left this painting unfinished, but it works fairly well with a relatively flat pictorial space. Although I modeled the face and shoes with strong values, I kept the coat and pants flat-looking and repeated their color in the surrounding ground.

Deanne Lemley
JAPANESE LANTERN
Watercolor on paper, 22 x 30" (55.9 x 76.2 cm)

Lemley clearly establishes the forward position of the objects in this briskly painted still life by painting them with intense color and value contrasts. But she then surrounds them with a neutral ground. By keeping the background uniformly light, she avoids creating deep pictorial space between figure and ground.

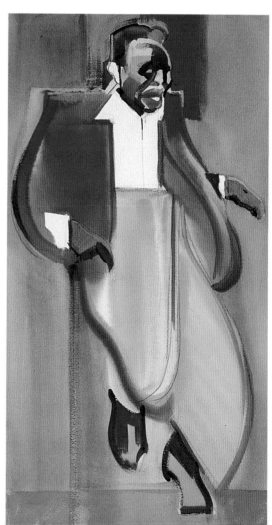

Here, I pushed my surrounding space back by muting it slightly with a light wash of cool, neutral color. The warmer, more intense figure is clearly advanced in front of the ground.

Kiff Holland
SUNDAY MORNING II
Watercolor on paper, 20 x 28" (50.8 x 71.1 cm)
Private collection

Holland avoids the integration of figure and ground in this beautifully rendered painting. But by darkening the surrounding space, he directs our attention entirely to the abstract patterns within his subject. Thus isolated against the ground, the crystal objects' reflective and transparent surfaces attract and hold our attention.

In this version I wanted deep space behind the figure. No color recedes as far as blue-gray or a dark blue. By painting the space entirely in a shaded blue, I've clearly separated and isolated the figure from its ground and have created deep pictorial space.

By painting the ground this time in a more intense, advancing color—yellow-orange—rather than in a dark, receding neutral, I restore a sense of flatness. There is a closer relationship between figure and ground. Note how a dark or light outline will flatten a form.

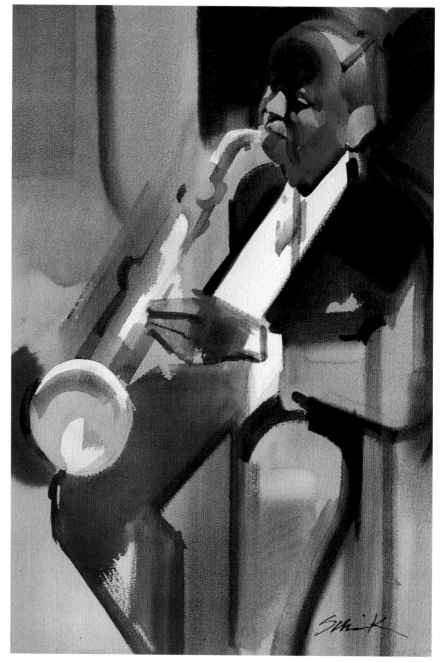

Christopher Schink
IN THE SECTION
Watercolor on paper, 30 x 22" (55.9 x 76.2 cm)
Collection of Brian Atyeo, Ontario, Canada

When you repeat in the ground a color or value from the figure (or vice versa), you bring them into a close relation, reducing pictorial space. Here, I flattened pictorial space by repeating both the darks and lights of the figure in the ground. Note, for instance, the deep dark on the jacket, which has been repeated in the ground behind the head, and the muted, lighter yellow that appears on the leg and arm and then again in the ground.

Alternating values—light against dark and then dark against light—closely relates figure and ground with an interplay that flattens pictorial space. I slightly muted the color in both the figure and ground to emphasize the alternations of value.

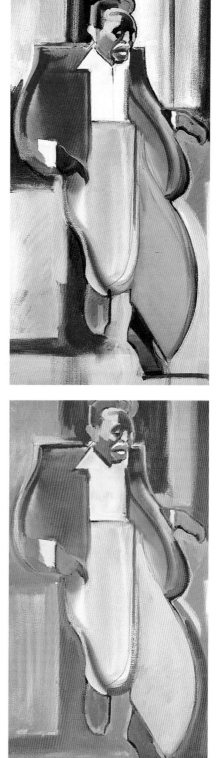

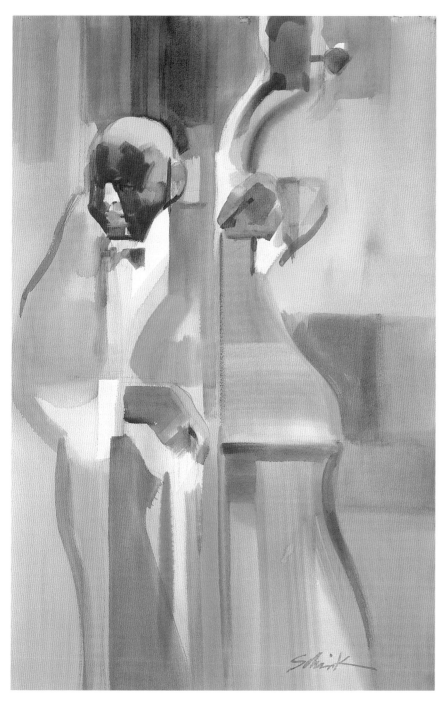

Christopher Schink
PLUCKING THE BASS
Watercolor on paper, 38 x 24" (96.5 x 61 cm)

By using a predominance of one hue and keeping the colors of the ground intense rather than neutral, I have flattened the pictorial space. I modeled the face using a fairly narrow value range to maintain a two-dimensional quality consistent with the ground. (The pink mouth and magenta bow tie are singular notes intended to break the monotony of the persistent green.)

Here, my alternation of warm colors—mainly yellow and rose—between figure and ground dominates the color scheme. This closely relates figure and ground as it flattens the pictorial space.

Oscar (Buddy) Folk
Landscape
Watercolor with oil pastel on paper,
22 x 30" (76.2 x 55.9 cm)
Private collection

Folk has used abstract forms in horizontal and vertical movements to suggest a landscape. But by avoiding any clear overlapping of these forms and by repeating similar color throughout, he creates a flat rather than a receding picture. The top of the painting seems as close to us as the bottom.

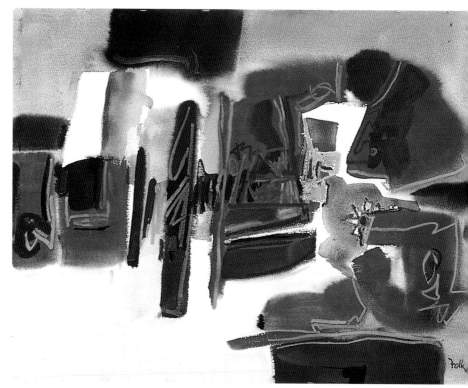

Christopher Schink
Jitterbugs
Watercolor on paper, 40 x 29" (101.6 x 73.6 cm)

My objective in this painting was to create a rhythm rather than an illusion of deep pictorial space. I repeated a violet throughout the painting for rhythm, and I repeated the ground's values in the figures. Note the mid-range violet that appears in both figures and ground, and the medium-dark colors used both in and around the woman's head. The pictorial space seems flat as a result.

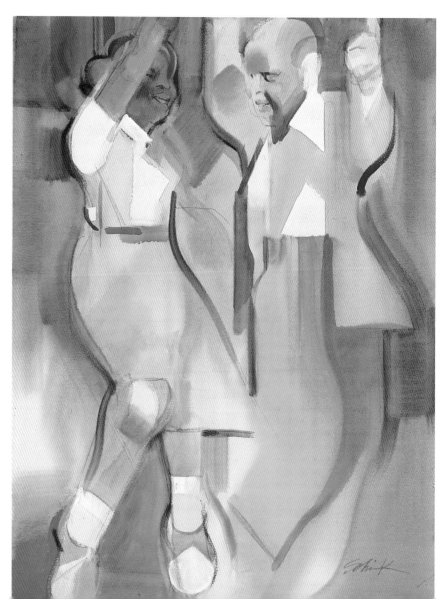

Here, I've used an interesting technique that will animate your pictorial space. By painting across the boundaries of figure and ground and using the same colors and values in both, I've created an ambiguous spatial relationship between the two. Parts of the figure seem to emerge from and disappear into the ground.

Alternating strong darks in figure and ground, I've used black here both as a local color and on shapes in the negative space. Although we think of black as receding, it will advance when used as a local color (as in the dancer's coat) or in contained shapes.

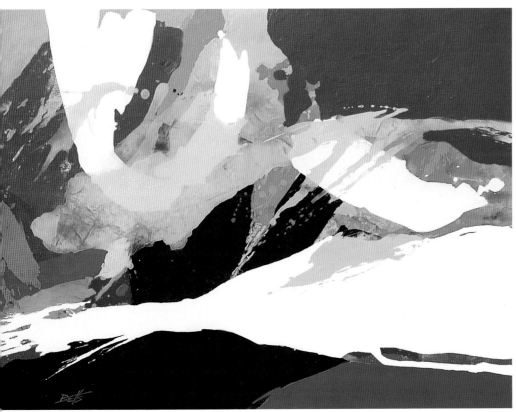

Edward Betts
FLOODTIDE
Acrylic on fiber board,
40 x 60" (101.6 x 152.4 cm)

In this seemingly spontaneous acrylic painting, Betts has skillfully used both white and black shapes as overlapping and overlapped elements. The effect created is a spatial ambiguity. When you use black in your ground it can create deep "holes"; but when you use black as a local color or as a defined shape in an abstract, it will advance or appear strongly fixed in space.

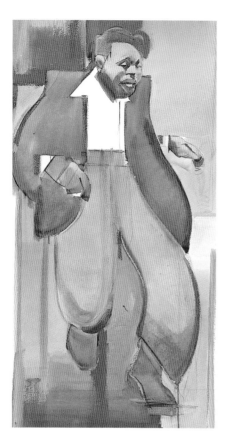

With watercolor you can easily attain smooth transitions in color or value. Here, I've used gradual, repeated shifts of color from warm to cool and kept the colors nearly the same in value. This sets up a spatial ambiguity that animates the pictorial space in the painting.

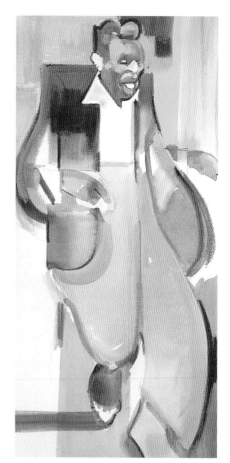

By freely alternating colors—orange, yellow, yellow-green, and white—throughout the painting, I've created an ambiguous and dynamic relationship between figure and ground. Many contemporary approaches to pictorial space are based on the "pushing and pulling" effect that results.

Alex Powers
SANTA FE
Mixed media on illustration board, 22 x 30" (55.9 x 76.2 cm)

By alternating value relationships between figure and ground—dark against light and then light against dark—Powers has created a flat but animated picture surface. (Note also his use of a more intense, advancing color in the ground.) His use of texture in both figure and ground reinforces the flatness and adds to the power of his statement.

CREATING THE ILLUSION OF STRONG ILLUMINATION

Some artists, like John Singer Sargent, could make their paintings seem to glow with sunlight. On close inspection, we find these impressive effects were created with nothing more than a white surface glazed with a few colors.

It is impossible in painting to reproduce the range of lights and darks and of color intensities that we perceive in nature. The value range in bright sunlight is a thousand times greater than any we can achieve with white watercolor paper and even the darkest paints. But we can create a convincing illusion of bright light by controlling our color relationships—especially by using sharp value contrasts.

Use intense color and lights and darks in sharp contrast to render a brightly lighted subject, as I've done here.

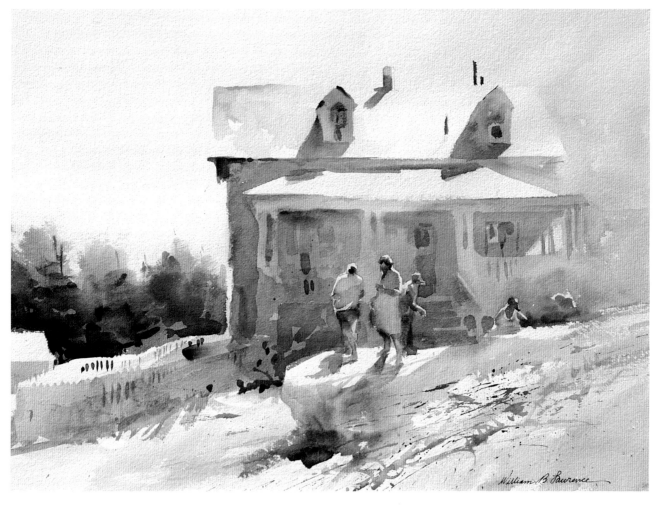

William (Skip) Lawrence
SUMMER COTTAGE
Watercolor on paper, 20 x 26" (51 x 66 cm)
Collection of Janet and Christopher Schink

Lawrence has depicted this scene using light tints and has limited his darks to a few carefully painted accents at the juncture of light and shadow. By using a full range of values, he has provided us with visual clues that convince us that the scene is strongly illuminated.

Color Constancy

To make our visual perception of the world more uniform and consistent, our eyes and minds adapt almost immediately to changing light conditions. We can come from painting in bright sunlight into an artificially lit studio and will only briefly notice the difference in the intensity and color temperature of the light indoors. Indoors, our paper seems as white as it did in sunlight; our colors seem as true and intense as they did outdoors. Color theorists call this phenomenon "color constancy." Quite simply, our judgment of the light we are seeing, either in nature or in a painting, depends not so much upon its actual brightness as upon the relationship between lights and darks; similarly, we judge intensities by judging colors *relative* to each other.

Thus, when viewing a painting, we rely on the range of values and other color qualities in it to give us visual clues as to the kind of illumination depicted. For example, it is only in bright light that we can see pure white and even pure black. In bright light, we see local colors at their greatest intensity, and the contrast in value between the illuminated side of an object and its shadow is also at its greatest. When viewers see strong lights and darks combined with bright, clean color in a painting, they are convinced that the illumination is strong.

Most descriptive landscape painters enjoy working with subjects in bright light. They can easily define the form and local color of objects and can attain a strong feeling of three-dimensionality and space in their paintings. Shadow patterns afford them an additional design element.

Less experienced painters find it easier to paint brightly illuminated subjects because subtle color mixing and careful control of values are not so essential. Some sense of bright light can be created with value contrasts or colors alone, but the most convincing illusion is created by adhering to the guidelines on the following pages.

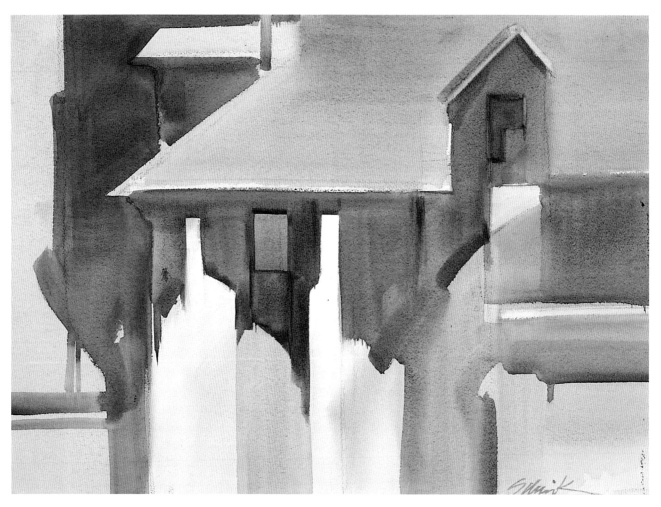

Christopher Schink
SUMMER HOUSE
Watercolor on paper,
22 x 30" (55.9 x 76.2 cm)

In this treatment of a house in bright sunlight, I convey a feeling of strong illumination by emphasizing contrasts of value where light and shadow meet. I added contrasts of hue also, putting yellow next to its complement, violet.

Value Range

Only in strong illumination can we clearly see the full range of values from brilliant sunlight to the darkest shadows, so to suggest bright light you should employ a palette ranging from pure white to deep darks and even black. You should especially emphasize the value difference between the sunlit side of an object and its shadow. Look for areas where you can play darker color against light to direct attention and achieve focus.

The more light values we see, the greater the illusion of brilliant illumination. To achieve the effect of a light-flooded subject, leave a large percentage of your watercolor paper white or very light. Limit your darks to small areas of contrast and focus. Rex Brandt, the California watercolorist and teacher, often gave his students the assignment of leaving 50 percent or more of their paintings white to reinforce this concept.

The size of your painting is also a factor. As Turner, with his large canvases, demonstrated, any light or color effect is more convincing when the painting is large enough to fill the viewer's field of vision.

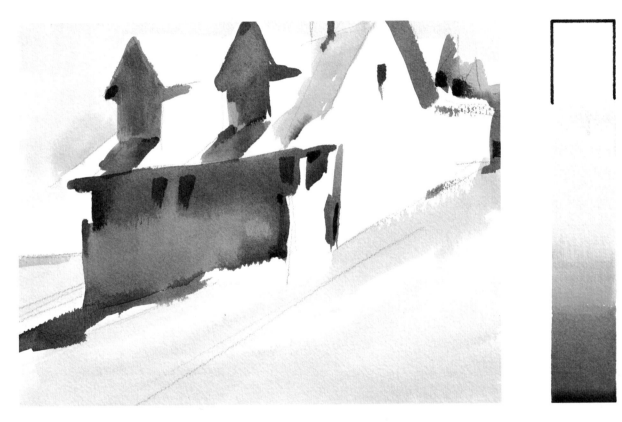

To convey the illusion of strong illumination, paint your subject in a full range of values as measured against a gray scale (like the one at right) that runs from pure white to black. Note that the lightest and darkest values on the scale are present in the picture.

Color Range

In bright light we often see the greatest range of colors, so choosing a wide spectrum, with the lighted areas of your subject weighted toward tints of yellow and other warm colors, will lend a sunlit feeling to your image. Make your light areas look even warmer (because of simultaneous contrast) by painting cool, shadowed areas that tend toward blue-violet and by adding a few cool accents as well.

Anne Adams Robertson Massie
JAMES RIVER FESTIVAL II
Watercolor on paper, 22 x 30"
(55.9 x 76.2 cm)

Massie uses a wide range of colors on a field of light yellow, and adds just enough dark accents to convince us that the scene is brightly illuminated. Her use of color in this painting is similar to the Impressionist approach described later on pages 115–116.

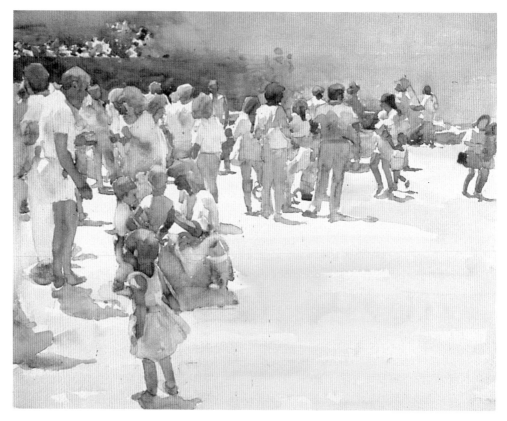

Intensity

In bright light, we see local color at its most intense. Though on occasion you may want to suggest a glare with bleached-looking colors (see page 53), normally it is best to keep your colors bright to give the impression of strong sunlight. Your darks do not have to be neutrals; in fact, more intensely colored darks suggest brighter illumination. Be careful of cold, blue darks, however; they can recede too greatly and seem to punch "holes" in the design of your painting.

Color and intensity range: In this diagram I have tried to suggest the full spectrum of high-intensity colors that you should use if you wish to suggest strong illumination. White and warm colors (top) occupy the greater area of the ring; your overall color scheme should be weighted toward them.

PROBLEMS AND PRACTICAL CONSIDERATIONS

Most of us have little difficulty painting brightly lit subjects; we use a lot of intense color and "sock in the darks." Yet occasionally I encounter students in my workshops having trouble achieving an effect of strong illumination. Let's look at some of the causes I've identified.

Problem: Wide value range, but low intensity

Although you may have created contrasts with a wide range of lights and darks, if your painting is done almost entirely with muted tints and shades, the illusion of bright light will be reduced.

The solution is to use intense color and white as well as clean-looking tints in the lighted areas—as Deanne Lemley's painting *Backyard, Cataldo St.* (below) shows. This will impart a sunlit quality to the subject. Also, even if the actual colors of the subject are more neutral, try finding a few spots where you can drop in pure color to convey the effect of brilliant light.

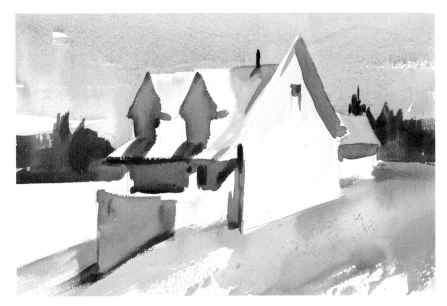

The wide range of values here suggests bright light, but the illustration still has a cold, dreary look. The solution is to introduce intense pure color, as I did in the earlier house illustration on page 81.

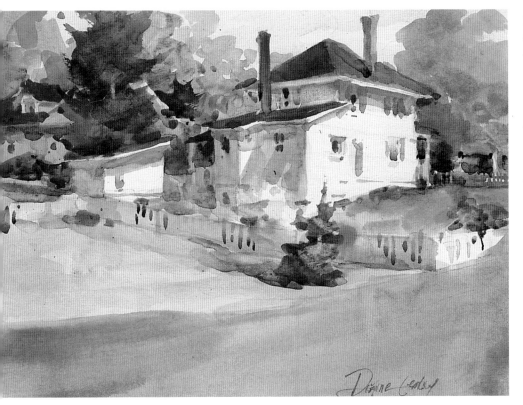

Deanne Lemley
BACKYARD, CATALDO ST.
Watercolor on paper,
22 x 30" (55.9 x 76.2 cm)
Private collection

Lemley has employed an almost complete range of spectrum hues—orange, red, violet, blue, green, and yellow—to suggest strong illumination. And although she has used a wide range of values, she has kept the painting predominantly light to strengthen the brightly sunlit feeling.

Problem: Plenty of light, but no sunlit quality

The right side of this painting was done almost entirely in thinly diluted colors, with no darks added. The result seems light-flooded and airy, but—because of the absent darks—not as powerfully illuminated as the left-hand side of the painting.

The solution is to add sharp accents. Simply by introducing a few well-placed darks at the edges of shadows and against your lightest lights, you can transform the painting into a brightly lit scene. Remember: Your darks can be rich in color—deep blues, reds, greens, and purples.

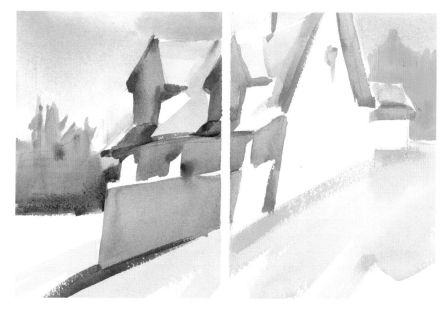

On the right side, the lights, painted with tints, suggest bright illumination, but the absence of any dark values reduces the effect. On the left side, note the improvement when a few dark areas are introduced.

Problem: Too much dark

Your subject, or perhaps your expressive intent, suggests a predominantly dark painting. For example, in a painting of a few sunlit flowers seen against a dark woodland setting, you paint much of your surface in middle-to-dark values for the woods. But then the effect of bright illumination on the flowers is not convincing. If darks occupy too much of the image area, the results will look more somber than sunlit.

The solution lies in the use of a little artistic license: Don't hesitate to lighten, brighten, or completely change the local color of the dark subject. After all, your objective is to convey a feeling of bright light, not to report exactly what you see. Try to reserve darks for small areas of importance.

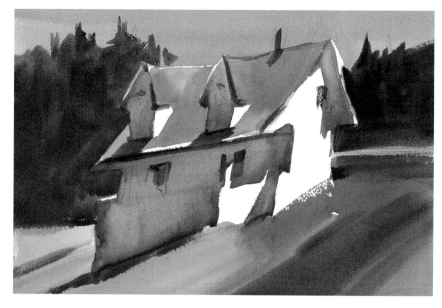

Here, the subject is engulfed by dark shadows. Sharp contrasts have been used to suggest strong illumination, but the predominance of middle and dark values reduces the illusion. Darks must occupy much less of the image area if you want a bright-light effect.

Notes on Technique

Unintentionally neutral color can result from the use of a palette that is too limited. Take for example a palette limited to such colors as phthalo or ultramarine blue with yellow ochre and burnt sienna. Such a palette would produce a wide range of lights and darks, but the colors would be too neutral to effectively depict a bright, sunlit subject.

Starting with a dirty palette won't help either. You can't get pure color unless you have a clean palette and fresh pigment.

Overmixing neutralizes color also. If, for example, you try to suggest reflected warmth in a violet shadow by brushing in yellow, the result will be a dirty gray. To retain intensity when introducing one color into another (especially complements), carefully drop or "charge" the color in, working wet-into-wet instead of brushing it around. In Skip Lawrence's watercolor *Summer Cottage* (page 81, detail below) we see a good example of how to use this technique.

You may find that you are having trouble with dark values because you misjudged your overall scheme of values. If you are going to use a full range of light to dark values, put a single, small dark in your painting in the early stages of the process. This should help you gauge where you are in the value scale, but remember to limit this initial placement of the dark value.

Some painters, to ensure that their paintings will have plenty of contrast, develop the bad habit of "punching in" large, strong darks during the earliest stages of their paintings. If you've developed this habit, in your next several paintings try leaving the painting unfinished for a day or two before adding any darks or details. You may be surprised at how few accents are needed to make the painting look brightly illuminated.

In this detail of Skip Lawrence's Summer Cottage *(see page 81), note the charged-in blue-greens in some of the shadowed areas. These intense accents add to the illusion of strong illumination.*

CREATING THE ILLUSION OF WEAK ILLUMINATION

There is a mysterious quality to subjects seen in low illumination. The reduced light affects our perception. Bright colors become more neutral, shifting to a unifying gray. And everyday subjects, easily recognizable in sunlight, take on an ambiguous quality. While bright illumination has always been a favorite of landscape painters, scenes with low illumination have inspired some great paintings. J. M. W. Turner and James Abbott McNeill Whistler were masters at depicting twilight and nocturnal scenes that were vague and impressionistic.

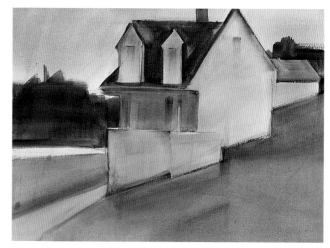

Use neutral color and avoid sharp value contrasts to render a weakly lighted subject, as I've done here.

Reduced Light, Reduced Information

You don't need to check the weather report or your watch to know that it's overcast or late in the day. As soon as you go out the door you can sense by the quality of light and color whether it is sunny or gray, afternoon or evening. In low illumination you see less intense color and a narrow value range. As artists we employ these visual clues in a painting to suggest low illumination.

Although you will find the effect fairly easy to achieve, you may find it more difficult to produce a satisfying painting, particularly if you have learned to depend on shadow patterns and strong value contrasts to animate your design. When you paint a subject in bright illumination you can clearly show its form, its actual color, the texture of its surface, and any visible detail. When you paint the same subject in reduced light, you include very little of this descriptive information; instead, you show primarily its outer shape. Your painting is not about things but about the quality of the light.

In this section we'll examine how the simple effect of low illumination is created. Atmospheric conditions in which low illumination is accompanied by other factors such as fog—causing objects to meld into simple, indistinct silhouettes—will be examined in the next section. For low illumination, you should be aware of the following guidelines.

Jerry Stitt
LOPEZ MORNING
Watercolor on paper, 22 x 30"
(55.9 x 76.2 cm)
Private collection

Because of the absence of strong lights and darks and the predominance of middle values and muted colors, dimly lighted subjects are difficult to make interesting. Stitt has used surface texture and pattern to animate what otherwise might have been a dreary subject. The result is a moody and evocative painting.

Value Range

The value range you use in your painting depends, of course, on the degree of illumination you're trying to depict—the light in late afternoon being different from the light at twilight. In either case, you must reduce your value range and eliminate pure whites and blacks. Weak illumination turns whites to grays. And even in the dimmest light, grays should stand in for blacks.

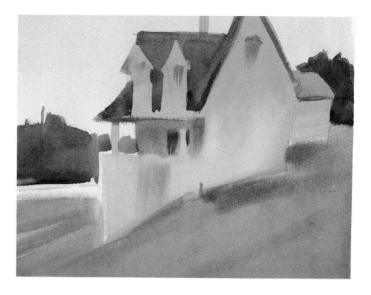

To convey the illusion of weak illumination, use a narrow range of values as measured against a gray scale that runs from light to dark gray—omitting pure white and black.

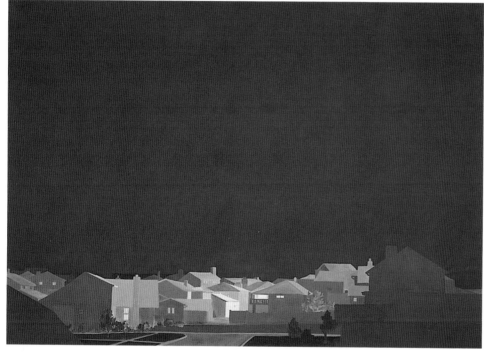

Barbara Kastner
Vigil #2
Casein and acrylic on paper,
29½ x 41½" (74.9 x 105.4 cm)

Working in casein and acrylic, Kastner has avoided pure black to create her nocturnal sky and used a velvety, cool dark. The effect is convincingly one of deep night.

Color Range

In low illumination there is an absence of warmth in the light, so use generally cooler colors (we especially associate blues and blue-violets with the twilight and nighttime hours). Avoid strong contrasts between complements (for example, a red boat with a green stripe). Although your color scheme will be predominantly cool, you should suggest some warmth in your foreground objects to utilize the effect of simultaneous contrast.

Color and intensity range: As the broadest areas of this diagram suggest, your palette should be weighted more toward cool colors if you want to create the illusion of weak illumination. All the colors you use should be muted.

Black and white in weak illumination: Use pure black and white only when you want to depict your subject strongly illuminated (as illustrated in the figure on the left). In weak light, your whites must really be slightly gray and less pronounced; blacks are actually slightly lighter than black. Although I grayed down the white beard of the figure on the right, we still perceive it as "white."

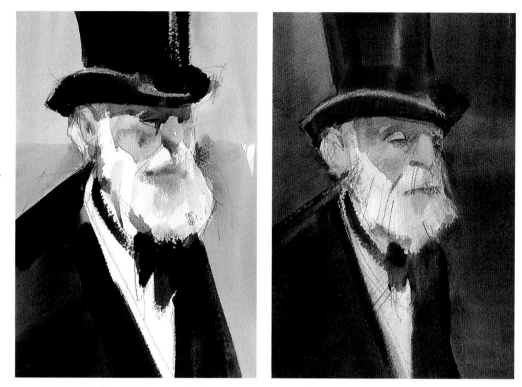

Intensity

We don't see bright colors in weak illumination, so your colors must be slightly grayed and generally cooler to capture the effect. Mute the colors you use and save the intense ones for other occasions.

Christopher Schink
LATE IN THE SEASON
Watercolor on paper, 22 x 30"
(55.9 x 76.2 cm)

I painted this beach house on an overcast afternoon and tried to capture the dim quality of the light. I eliminated all whites with an initial wash of violet and green-blue (on the roof) and then painted my darker shadow areas in violet. To strengthen the overall gray-violet effect, I used some complementary yellow in the shadows.

PROBLEMS AND PRACTICAL CONSIDERATIONS

Most of us don't go out very often after supper to paint or even think to observe the appearance of color in low light. To convincingly render the evening's light, simply washing a neutral tint over a bright, sunny watercolor won't work. And even when you conscientiously follow the guidelines explained above, you may find yourself resorting to old habits that destroy the illusion of limited light. Here are some typical problems:

Problem: Kicking the shadows habit

You may not be aware of how much you rely on shadow shapes to animate your painting's design until you try to create the illusion of weak illumination. Many painters tend to do it automatically. But with a dimly lit subject, as soon as you paint a strong shadow you ruin the effect.

You must have shadows, but they must be weak.

The solution is to concentrate on finding interesting silhouettes. Look for a subject with a more varied and interesting shape, or group several objects together to create one.

You may be in the habit of using strong shadows to animate an uninteresting shape like the vase of flowers on the left. But if you want to create the illusion of weak illumination, you can't depend on such shadows because we don't see them dim light. Instead, your subject needs to have a more interesting shape, like the one on the right.

Problem: Overly varied color

Using a variety of bright hues is another habit you may have developed in painting, but it won't help you with dimly illuminated subjects. You may make attractive paintings playing complements off one another, but it will destroy the low-light illusion you seek. We see neither intense colors nor a wide range of them in meager light, so these cannot be your focus.

The solution is, first, to depart from local colors.

Second, think in terms of simplified blocks of color. Your emphasis on silhouetted shapes lacking in interior detail will provide you with opportunities to play with contiguous, cool, and muted colors in appealing ways. Save the rendering of color variations within the outlines of your subject for another kind of painting. Here, you're trying to convey a quality of light, not a description of objects.

"Juicing in" color, too varied or too bright, is a device some painters habitually use to animate a picture. Here, I have added some intense color detailing to my dimly lit subject (using pastels) and lost the lighting effect I was after.

Sometimes, finding a different viewpoint—above, below, or to the side of your subject—is the solution that animates your image. Here, I have discovered more distinct and interesting shapes in a house motif. I have treated them as simple blocks of muted and cool colors and avoided interior detailing.

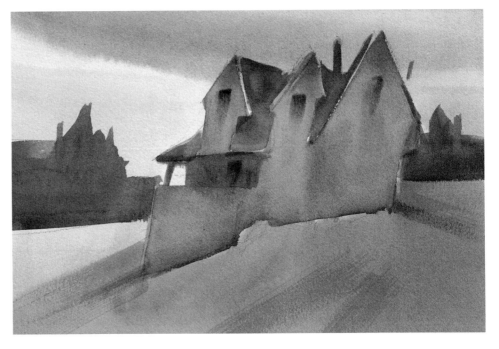

CREATING ATMOSPHERIC EFFECTS

The perception of light and color is, as we've observed, greatly affected by atmospheric conditions, particularly wet ones. Water vapor in the air—whether we call it haze, mist, or fog—and rain, sleet, and snow pose challenges not only to mail carriers but to artists. Because these conditions diffuse light to a great extent, a painting that captures atmospheric effects can be dramatic or soft and romantic.

Like low illumination, atmospheric conditions such as rain and mist obscure detail. As we look through a heavy layer of water or water vapor, light looks gray. Distant objects are hidden altogether, and because of the scattering of light, closer individual objects blend into gray silhouettes. Subjects take on a poetic quality and become shrouded in mystery as forms become soft and blurred.

J. M. W. Turner, who loved the drama of nature, actively sought out thunderstorms and hurricanes. He is reported to have had himself lashed to a ship's mast during a stormy channel crossing to experience the weather's fury. You may be excused from such an experience. You can re-create atmospheric effects in your paintings if you apply certain principles.

The increased amount of atmospheric vapor between you and your subject creates an exaggeration of the effects we considered under "Aerial Perspective" (see page 38). We see no pure whites or blacks. Your palette, then, must be muted, with a predominantly cool gray cast. The range of values must be very narrow, and color intensity must be greatly reduced on even slightly distant objects.

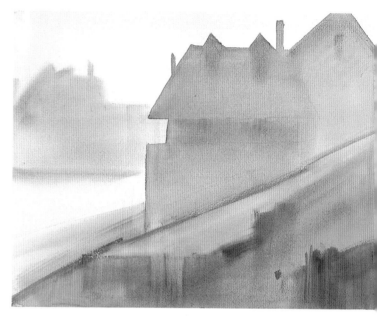

Use grayed-down color and a greatly reduced range of values to capture the effects of diffused light, as I've shown here.

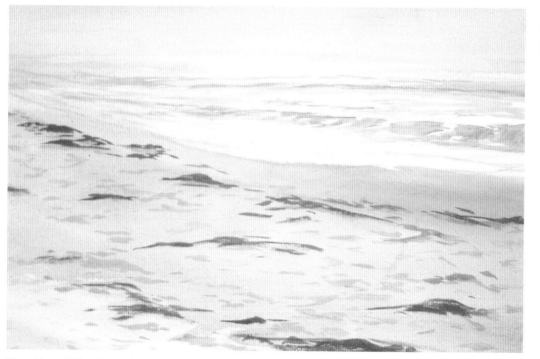

Thomas McCobb
GOOSE ROCKS
BEACH
Watercolor on paper,
22 x 30" (55.9 x 72.6 cm)

The subject of this subtle, quiet painting is nothing more than light mist on a Maine beach. McCobb shows a keen eye for the effects of diffused light and a skillful control of values. He has used muted colors throughout and limited almost the entire painting to light and middle-light values, creating the convincing illusion of quite specific atmospheric conditions.

Value Range

Start by tinting your paper with a light, overall wash of a cool color—blue, blue-green, gray-violet, or even brown (if you live in a smoggy city). In fog, whites are less pronounced and should be grayed slightly. Your values and color choices will depend on the atmospheric conditions and quality of light you wish to suggest, but this first wash should eliminate all pure whites.

Even in a light mist, your value range should not extend much past middle values, and you should avoid using black. Still, some contrasts are desirable to create the proper illusion: In fog, mist, and the like, *closer objects are darker and distant objects lighter.*

To create atmospheric effects, after toning your painting, paint the lighter, distant elements of your subject first. Keep the forms flat-looking, with little or no light–dark variations within them, depending on how heavy a mist you're trying to suggest (that is, the heavier the mist, the flatter and more unvaried the shape). Then, over the distant shapes, superimpose darker, closer objects to which you give some subtle interior value shifts.

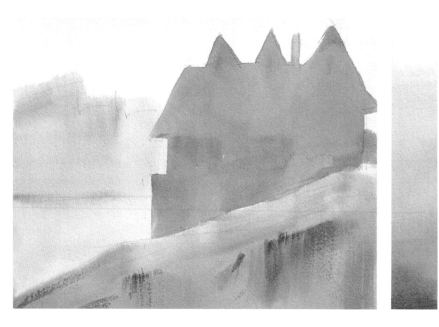

Value range for atmospheric effects: To convey the illusion of a heavy mist, paint your subject using a very narrow range of values, as measured against a gray scale that runs from light to dark gray. Avoid using pure white and black.

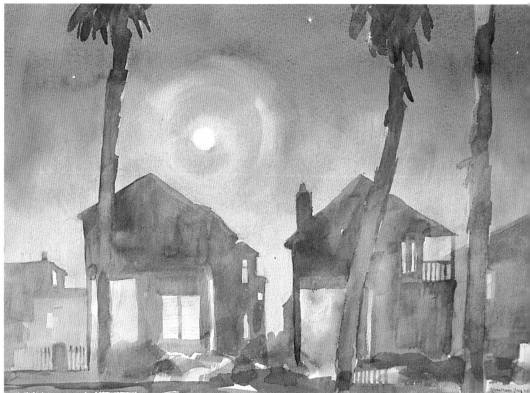

Joan Irving
BLUE MOON
AT GOLDENROD
Watercolor on paper, 22 x 30"
(55.9 x 72.6 cm)

With a marvelous control of values, Irving has captured the effects of mist. By employing predominantly cool, muted color she has given an unimpressive subject, a neighborhood, a poetic and almost mysterious quality.

Color Range

Heavy atmospheric vapor not only grays local color but tints it with a predominant color. A misty dawn or sunset light would make this a warm tint, but most of the time wet conditions and dim light will dictate a cool one. Again, an initial, overall wash of a cool hue will help to establish this dominance.

Simultaneous contrast can be exploited to somewhat widen your color range. In the close-up objects in your composition, you can use a muted complementary color in contrast with your picture's predominating color; usually, though, you should simply paint them warmer against the distant objects, which are painted in cool colors similar to the predominant color.

Heavy atmosphere not only grays local color but also tints it. Because of simultaneous contrast, your foreground objects can be made to appear warm in contrast with a prevailing cool light. This diagram thus shows that while your palette should be weighted toward muted cool colors, you can use some yellow or orange and still maintain the effect of a mist or fog.

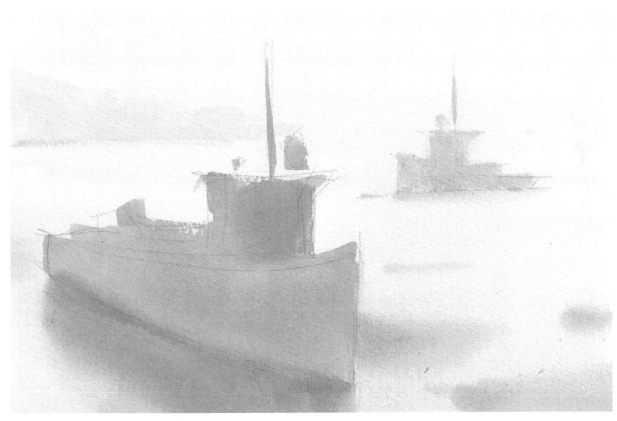

As this picture shows, the effect of fog or mist is created by painting your close-up objects darker and warmer and your distant objects lighter and cooler—or completely obscuring the distance.

Intensity

Mist and fog (along with weaker light) neutralize colors. To suggest these conditions, you should work exclusively in muted tints and, for close-up objects, in shades. Remember: Only in strong light can we see bright local color. In mist and fog you must paint even intensely colored objects as neutrals.

Color range in rain: To create the effect of rain, paint the reflection of the reduced light of the sky on the top planes of objects, as I've done here with the horizontal surfaces of these boats. You can make your darks appear deeper in rain than in mist or fog; avoiding strong contrasts of light and shadow, give your local colors more richness and variety (to look rain-soaked) than you would for a fog-shrouded subject.

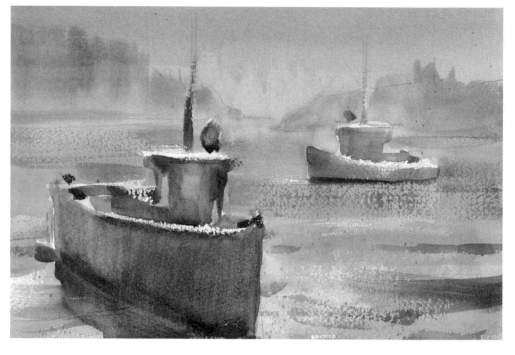

Gerald Brommer
HALF MOON BAY
Watercolor on paper, 22 x 30"
(55.8 x 76.2 cm)

Watercolorists love the technique of making shapes light and surrounding them with darks to create a focal point in their paintings. But in fog, close-up shapes become shades, while distant elements become light gray silhouettes surrounded by light, neutral color. Here, Brommer uses grayed-down colors to create a convincing illusion of atmospheric mist.

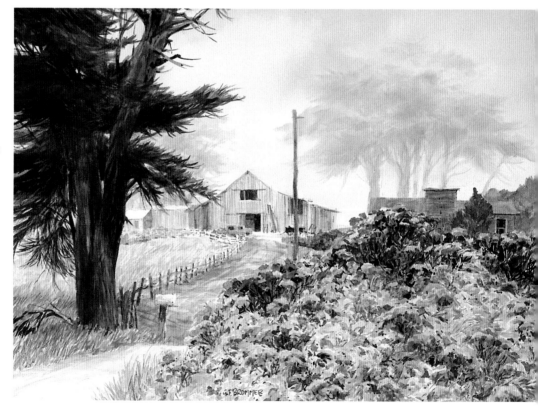

PROBLEMS AND PRACTICAL CONSIDERATIONS

You may have accidentally gotten the effect of fog in a painting when you forgot to clean your palette thoroughly or, possibly, started working wet-into-wet on a too-saturated paper, making everything either dirty or too fuzzy and light. When you wanted to suggest a misty atmosphere you may have accidentally ruined the effect by resorting to old habits—leaving the whites, socking in the darks, and so on. These are common errors.

Problem: Whites that don't work

You probably learned in your first watercolor class always to leave some strategically placed whites in a painting, and you have done so ever since. Or, to give your painting "sparkle," you may use a rapid, light brushstroke that skips and misses, leaving small spots of white paper. But these tricks can't be used if you want to create atmospheric effects like fog convincingly.

The solution is initially to cover your watercolor paper with a cool, slightly neutral wash to eliminate any pure white.

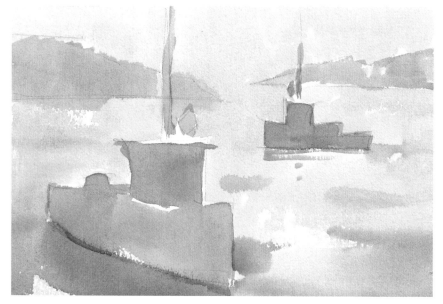

Saving white areas is common practice in watercolor painting. Here some white spots were left unpainted on the boats and the water. These areas, however, can only appear to be places where a bright shaft of light has penetrated—spoiling the effect of a mist or fog.

Problem: Making it brighter

Some painters rely on small areas of bright color—orange chimneys and distant figures in red jackets—to animate the color in their paintings. You may have been tempted to pop in a few bright colors to pep up a gray painting in which you created the illusion of atmospheric mist. You may have wished to use differences in local color to distinguish one object from another. After all, a picture of pea-soup uniformity wasn't what you were after. But the effect you had wanted was lost.

The solution is to blend, not jump, from one color to another—but it must remain muted color. You cannot use brighter color to animate the painting; the whole effect of mistiness will be lost. Take advantage of the effects of simultaneous contrasts among your muted colors, particularly in foreground areas of the painting where the atmosphere veils objects the least.

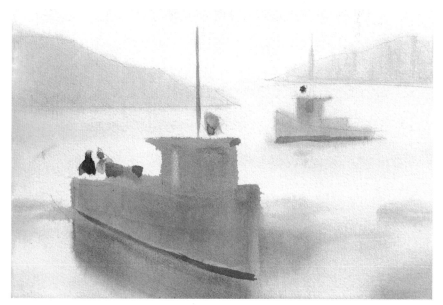

I'm not sure whether always adding accents of intense color is just a habit or some disease that strikes one out of three watercolorists. Anyhow, as I've demonstrated here, it doesn't work in fog paintings!

Problem: Uninteresting shapes

You have carefully followed all the guidelines I've suggested above and still have come up with a dull picture. Your convincingly painted fog is, in itself, not very interesting, and you feel you've painted nothing but pile of gray mashed potatoes.

The solution is to rethink your choice of subject. George Inness, the great American painter, was only partly right when he said, "Subject is nothing, treatments make the picture." The subject is not negligible in the case of atmospheric effects, for you must choose interesting contours. When viewed through fog, conventionally picturesque subjects may have dull, uneventful silhouettes. Otherwise ordinary subjects may have far more interesting shapes, even when they are blurry. Look for the geometry, and forget the interior areas where the details usually are.

In fog or mist, you see no interior shadows or details, so unless a subject or viewpoint gives you interesting and varied silhouettes, the results can be— as they are here—dull indeed.

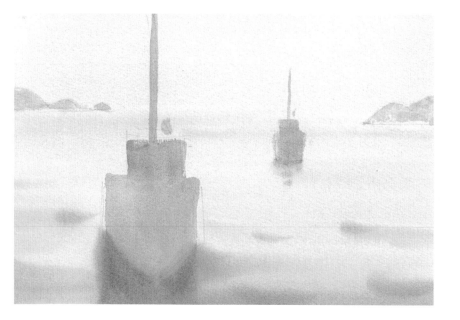

William (Skip) Lawrence
FOG AT PEMAQUID LIGHT
Watercolor on paper, 20 x 26"
(50.8 x 66 cm)

Lawrence views this lighthouse through a veil of mist that gives it a mysterious, lonely quality. Note how, to emphasize the prevailing cool light, he has painted the closest foreground forms with touches of warmer yellow-greens.

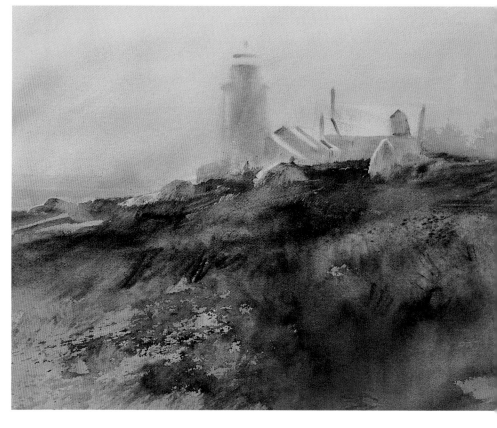

CREATING THE EFFECT OF LUMINOSITY

Paintings are often described as having color that "glows" or even "sings." There are areas in them that appear to emit light or seem neon-like. What we're responding to is the effect of luminosity. A glowing sunset, light shining through the blossoms of a fruit tree or from a Japanese lantern—these are examples of the luminous effect that we can create in a painting.

You want to distinguish between luminosity and illumination. Illumination describes the light shining *on* an object or area. Luminosity describes the effect of light shining *from* or *through* an object or area—like the light shining from the windows of the house seen here.

Strong illumination calls for strong value contrasts and intense color; but luminosity requires a somewhat narrow value range and some large areas of neutral color. Surprisingly, to achieve the effect of luminosity you don't "save the whites" of your paper.

In a painting of light shining through the transparent surface of a breaking wave or through foliage, *the areas that appear luminous are both the lightest and the most intense in color.* Areas surrounding them are slightly darker but are always neutral. As for signs of bright illumination, there are either slight effects of sharp value contrasts *well removed* from the luminous areas, or there are none at all.

Because of color constancy, we perceive the light areas as luminous. That is, our judgment of these color areas depends not upon how bright they are but upon their relationship to other colors. Because of the absence of white and the subtle contrast with the surrounding neutrals, light from the light-colored areas seems to spread, or overflow—a glowing effect. Thus, in creating luminosity, if you allow competing areas to be either lighter or more intense than the area where you want the glow, the illusion will be reduced or lost.

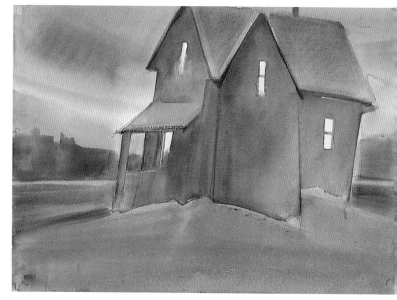

In both sky and windows, I created the effect of glowing light by painting with a reduced range of values and tints of pure color.

To illustrate the difference between luminosity and illumination, on the left I've painted the flowers in a wide range of values; there are strong contrasts along with intense color to create a sense of strong illumination. On the right, I've narrowed the values from light (but with no whites) to about mid-range. I avoided strong darks. Then I created the glowing leaves with tints of pure yellow and neutralized all the other areas in the painting.

The effect of luminosity is created when small areas of light, pure color or pure-color tints are surrounded by larger areas of mid-range neutrals that are carefully adjusted in value. We judge these horizontal lines to be emitting light and the upper "sky" area (done in similar horizontals) to be glowing because there are no detracting lighter areas.

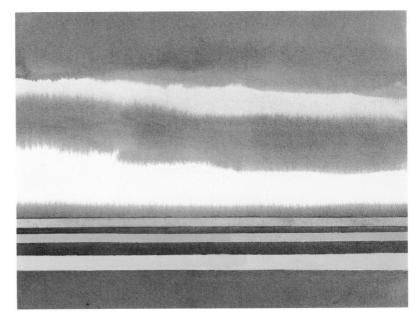

William (Skip) Lawrence
WINTER DRAMA
Watercolor on paper, 28 x 34" (71.1 x 86.4 cm)

Lawrence is a master at capturing the effects of light on the landscape. Here, he has used a few yellowish tints and slightly darker violet-grays to convey the soft glow of winter light on a snowy scene. He has worked in a narrow value range—off-white to barely mid-range—and limited his dark accents to a few strokes that he keeps well removed from the sky.

Value Range

For luminosity, the lightest areas in a painting must be light, pure colors or pure-color tints that are surrounded by *slightly* darker areas. In other words, your values must range from off-white to medium-light for the tints, and no farther than mid-range for the neutral areas. Even small slivers of white or real darks in the luminous areas will spoil the effect.

The illusion of luminosity is most effective when kept to small areas. Although a great colorist like J. M. W. Turner was able to make four feet of canvas seem to glow, you'll have more success if you make the majority of your painting surface—say, 80 percent or more—medium in value (and muted in color).

Value range for luminous effects: To create the illusion of glowing areas, paint your subject using light to mid-range values only—no pure whites and no darks. Compare the gray scale with the values in the painting.

Color Range

Luminosity can really be achieved with any pure spectrum color, but the ones that are both light and intense work best. The pure color that fits this description best is, surprisingly, yellow-green. It will invariably appear luminous when surrounded by neutrals. Because of their intensity, yellows and yellow-orange also work well. Greens, blue-greens, red-oranges, and reds must be lightened and used as tints to be effective. When dark hues such as violets are sufficiently lightened, they lose much of their intensity and can be more difficult to use for a glowing effect.

I have designed this color diagram to suggest that you should weight your picture toward the mid-range neutrals (bottom), and put light, intense colors (top) in small areas to create the effect of luminosity.

Intensity

Again, the luminous areas in a painting must be not only the lightest in relation to all the other areas, but also the most intense. In order for these "glow" areas to be convincing, the adjoining areas should be made slightly grayer. You might start by painting a large neutral ground that will surround your luminous area. Gray-violet is a most effective neutral complement; it seems to enhance any other color you'd choose.

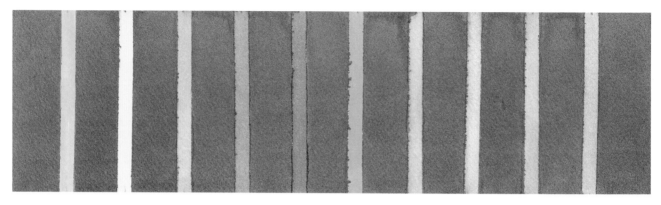

You can most easily achieve the effect of luminosity when you surround small areas of intense color with a predominance of somewhat more neutral color. As you can see in this diagram, yellow-green and yellow look very luminous because they are light at full intensity. The last four bands on the right, though light, do not have the necessary intensity.

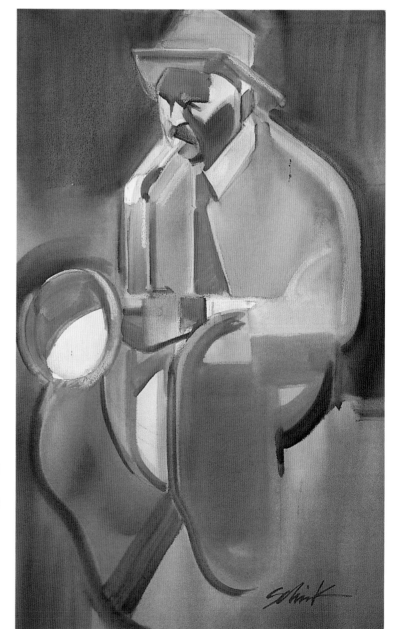

Christopher Schink
MIDNIGHT BLUES
Watercolor on paper, 24 x 38" (61 x 96.5 cm)

Luminosity does not have to be limited to particular effects of light. You can use it as I have done with this figure—or even in a nonobjective painting—to create an overall surface glow.

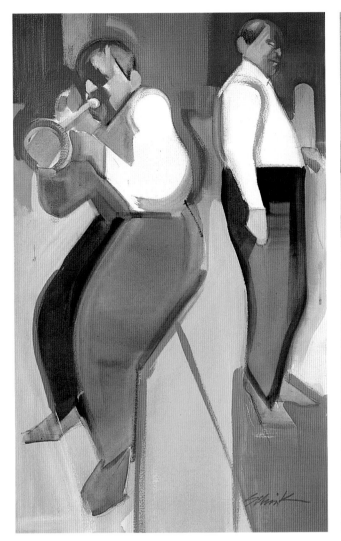

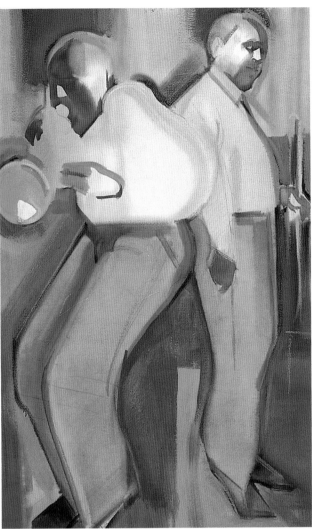

Christopher Schink
JAM SESSION 1
Watercolor on paper, 24 x 38" (61 x 96.5 cm)

Christopher Schink
JAM SESSION 2
Watercolor on paper, 24 x 38" (61 x 96.5 cm)

I painted both of these versions of the same subject in an entirely different range of values. In Jam Session 1
(left), I used a wide range of values with areas of pure color and white to suggest bright illumination. But in
Jam Session 2, *I wanted to evoke the eerie, late-night atmosphere of a jazz club with luminous color. I
narrowed my values, pulled back on color, and avoided whites. The muted color surrounding the yellows and
yellow-greens makes those areas appear luminous.*

PROBLEMS AND PRACTICAL CONSIDERATIONS

Luminosity is an effect many painters achieve unknowingly. Years ago, after stopping midway through a painting to admire the glowing surface I had created, I added finishing touches of darks and juicy color. The final result was disappointing, for the glow had disappeared. To create the illusion of luminosity, you must control the values and intensity of your colors.

Problem: Slivers of white

Even a small sliver of white on the edge of a luminous area will destroy the effect. If you are a painter that works in an expressively "brushy" style, you may have trouble creating this effect. Your end result will have whites that appear to flicker, taking away from the glowing effect you want.

The solution is in the way you begin. For painters who habitually leave whites, a simple solution is to begin a painting by washing all the areas that are *not* to be luminous with a flat, neutral color, then carefully filling in the light areas with tints and pure colors. After that, you can dance with your brush all you want. For luminous effects, you must fill in the light areas carefully.

If you work in a loose, painterly style, your painting may sparkle, but it won't glow. The lightest areas in your painting should not be white paper. You'll have more success if you start with flat washes and paint in all whites before you add any calligraphy-style brushwork.

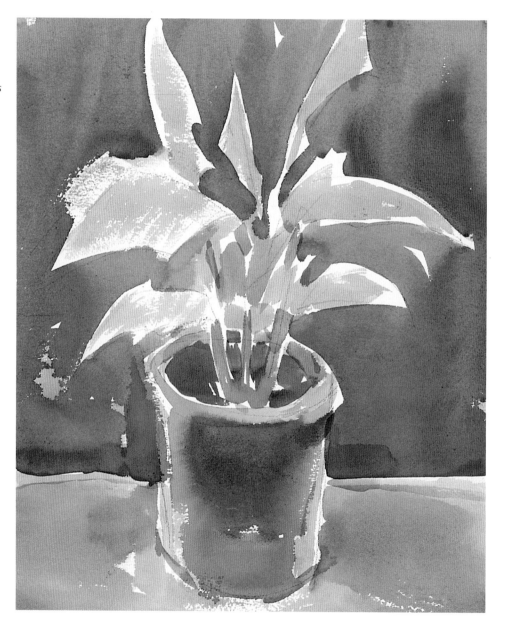

Problem: Putting in effective darks

Either from habit or desperation, most of us have come to rely on the addition of a few strong darks next to our lights to pull our paintings together. Although this technique works most of the time, strong darks, just like whites, reduce or ruin the illusion of luminosity.

The solution is to reduce your value contrasts and to keep your darks well away from the luminous areas. When you want a glow, you should use only a few dark accents, so that mid-range values dominate. You will achieve the focus you need by contrasting the small glowing effects against the larger areas of neutral color—not by playing dark against light.

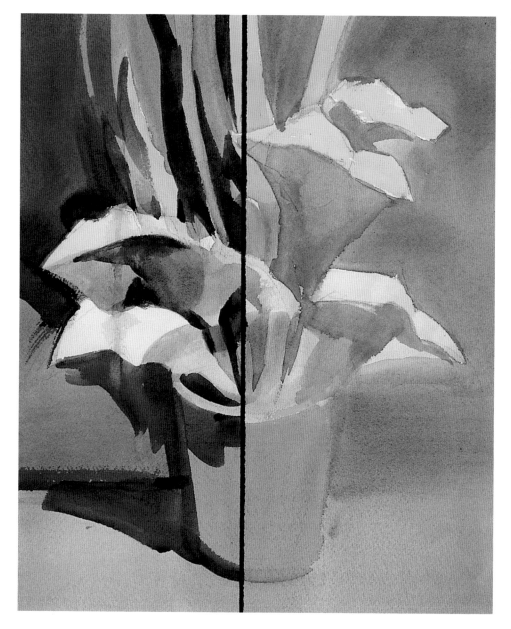

It's tempting, when you get a painting to the stage this one has reached on the right, to "punch it up" with a few good darks—as I've done on the left-hand side. Most of us do this from habit. The results are stronger contrasts, but a loss of luminous effect.

Problem: Lights that don't glow

You find you are not having success getting a truly luminous effect; your luminous areas are too dull, and even dirty-looking.

The solution is to make sure your lights truly *are* light, and to keep to the cleanest-looking tints and pure colors possible for your lights. Certain color choices are to be avoided because they are not pure colors; for this reason, yellow ochre, Indian red, and raw sienna are not effective. I've had success with permanent rose (quinacridone red), phthalo green, and a variety of clean-looking yellows—aureolin, Hansa, Winsor, and cadmium lemon.

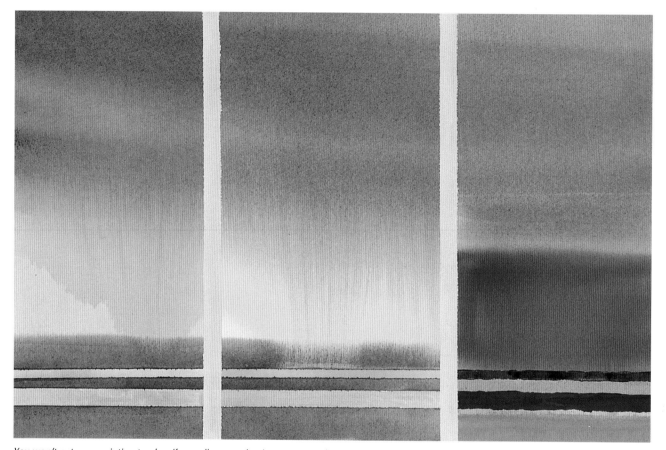

You won't get your painting to glow if you allow your luminous areas to become grayish (as on the right) or too dark (as on the left). Note the luminous effect in the middle section. And remember: Middle-valued hues such as reds and greens must be lightened to become tints that are lighter than the surrounding neutral ground.

Notes on Technique

Skips in the paint, "crawlbacks," and drybrush effects may be part of your style or simply the result of using a brush that doesn't hold enough paint. If you want a glowing effect in your painting, begin with a wash done with a large, flat brush, and then switch to smaller round and flat brushes for your expressive brushwork.

If you can't break the habit of punching up your paintings with darks, try limiting your palette to four or five tints and four or five middle-value muted colors. (See the "middle-value, muted palette" recommended on page 141.) You'll be surprised at how varied and successful the results will be.

And if, even with the best intentions, you still find yourself reaching for colors that are too dark or not pure (such as alizarin crimson, phthalo blue, and Payne's gray), try taping over the paint wells on your palette that contain these colors. Eventually, you'll break the habit.

Speaking of your palette: Despite what some painters think, a dirty palette does not mean you're an artist. Never try to paint luminous areas with dirty paint or a dirty palette. I recommend that you clean your palette and water after you have painted your neutrals. Then be sure to squeeze out plenty of fresh paint.

4 APPROACHES TO COLOR

There are painters who transform the sun into a yellow spot, but there are others who, with the help of their art and their intelligence, transform a yellow spot into the sun.

PABLO PICASSO

Many painters in the past have worked in what I call a *conceptual* way with color. That is, they have employed an approach based more on preconceptions about how to use value contrasts, or juxtaposed complements, or some other facet of color than on the actual colors and light conditions they have observed. In this section, I describe eight color approaches that have had great influence on painters, past and present.

"A good painting, like a good violin, should be brown," a 19th-century British art collector reportedly said. As you thumb through any book on the history of painting from the 16th to the mid–19th century, it may seem that most painters lived in a sea of brown gravy. In paints, spectrum colors were not as attainable as they are today. The color scheme in which warm, golden color was surrounded by deep, dark browns became a *convention.* Although it may seem somewhat dreary and unreal to us, this convention was convincingly realistic to earlier viewers. The world that Rembrandt lived in was not different in color from ours, although it was often more dimly lit. He and artists who accepted the same conventions simply imposed on their subjects a formal color scheme.

In the history of art we find painters developing novel uses of color that eventually became accepted. Rembrandt, Rubens, Veronese, Delacroix, Turner, Monet, van Gogh, Matisse—these were just some of the artists who influenced not only how we use color but also how we see color. Many artists did begin with their perceptions—Monet and the Impressionists used heightened color to suggest the play of light and shadow in nature—but their color schemes developed into various approaches that we continue to use today.

I often present a brief history of color in painting to my students. I suggest they apply at least two or three of the different approaches to the same subject, as I do with a portrait in the following sections. To make each approach easier to identify and remember, I have titled it after the artist or artists most frequently associated with it. But I do not mean to suggest, for example, that J. M. W. Turner was the only artist to use the "Turner" approach—or that he used no other. Also, I am presenting generalizations of how color was used in the past; they are not immutable laws to be followed blindly. After all, these approaches were developed by creative artists who departed from the rules and conventions of their time and even from their own radical new formulas.

"TRADITIONAL" COLOR

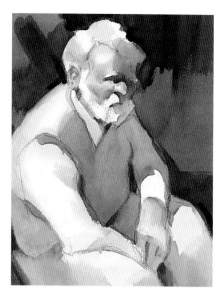

A painter's approach to color is not based solely on combinations such as the juxtaposition of complementary hues (red vs. green). Certain schemes, based entirely on the color wheel, such as "split-complementary" schemes (for example, red vs. blue-green and yellow-green), are often more confusing than helpful. The ways artists use colors that are modified—lightened, neutralized, and so on—are more to the point.

The color scheme most commonly used in realistic painting was first employed by Leonardo, who moved Renaissance painting away from a flat, decorative treatment of subjects toward a three-dimensional approach filled with light and shadow. We continue to use this approach today. Most of us learned to use color traditionally, starting with lights, painting muted colors for shadows, and putting dark shades in for deep shadows. Although you are constantly coached to leave areas of untouched white on your watercolor paper, an important aspect of this approach is that you do not leave whites; your lightest values are tints. Historically, most painters have kept their darks warm, to avoid deep, receding darks that would upset the pictorial space of the painting.

This portrait done in "traditional" color employs the color and value choices shown below.

Lights: In this approach your lightest areas are tints. Yellows, of course, will create a feeling of warm light. Also use blue-violet tints to suggest cool highlights. Here, I diluted permanent rose, cobalt blue, aureolin, and cadmium orange for my lights.

Middle values: In the areas where the local color of an object moves into shadow, paint the light-middle to middle-dark values with cool muted tints. Here, my neutrals are based upon mixtures of permanent rose, aureolin, gamboge hue, and cobalt blue.

Darks: Paint your darkest values with shades mixed from pure colors and either a small amount of black or a complement of the color. These shades are based upon mixtures of alizarin crimson hue, gamboge hue, French ultramarine, and Winsor violet.

Color Organization

Renaissance painters, working with a limited number of pigments, usually kept their colors on the warm side of the spectrum. Surrounding warm, light areas with cooler areas created a convincing illusion of three-dimensionality and depth. In traditional realistic painting, cool lights and warm darks seem less natural.

In the traditional approach, you employ muted tints and shades that move from brown to gray-violet to blue-gray. Earth colors, such as burnt umber and raw sienna, work well in this scheme.

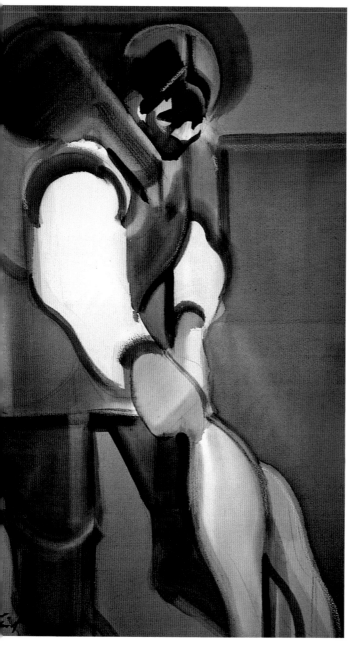

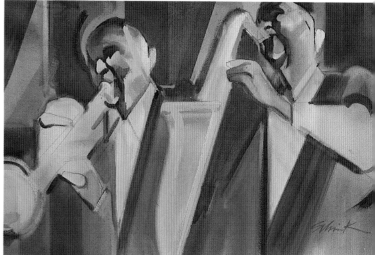

Christopher Schink
DUET IN BEIGE
Watercolor and acrylic on paper, 24 x 38" (61 x 96.5 cm)
Collection of Tad Schink

The wide value range—tinted lights, muted middle values, and deep shades—of traditional color is best suited to conveying a sense of volume and depth. Here, I've followed the traditional approach but alternated and repeated color and values between the figures and background. The three-dimensional forms thus do not look too rounded or positioned in deep space.

Christopher Schink
INUIT FISHERMAN
Watercolor on paper, 38 x 24" (96.5 x 61 cm)
Courtesy of Deagle Gallery, Jasper, Alberta, Canada

I used traditional color to convey a feeling of dusk and to suggest the solid forms of Eskimo sculpture. I painted the lightest areas with tints—yellows and blue-greens—and the middle values in muted tints, making them cool and gray in the negative space to suggest the far north's low illumination. But I painted the darks in deep, warm shades.

"REMBRANDT" COLOR

This portrait painted in a "Rembrandt" approach employs the color and value choices shown below.

Rembrandt's use of color and light was as revolutionary in the 17th century as the Impressionists' approach was in the late 19th century. While he explored a variety of styles throughout his career, it was his dramatic use of strong light and dark patterns and pure color that made his work so distinctive and different from the traditional approach of Leonardo. Rembrandt reduced the light passages in his paintings to a few linked areas of pure color and warm tints and surrounded them with large areas of deep shades, giving his subjects an almost magical inner glow. His strong contrasts of value between the illuminated and shaded areas made his figures seem mysteriously to emerge from or disappear into the background.

Other 17th-century painters, such as Caravaggio and the Dutch Tenebrists (a word denoting painters of shadow), restricted their light source in their compositions—a single window or doorway admitting bright light into a dark room—to create dramatic and often theatrical lighting effects.

With this approach you can create drama also. Most people (and even some painters) associate watercolor only with light, delicate washes of color. They can't imagine anyone applying paint straight from the tube onto the paper with little or no dilution. But that is what you should do in using "Rembrandt" color. (As in the previous approach, you leave no areas of white on your paper.)

You won't find it very difficult to reproduce the Rembrandt-like color scheme; of course, the Dutch master's genius was in his ability to convey powerful psychological insights and a deep feeling for the human condition, not just in using a little pure color and burnt umber.

Lights: Limit your light-valued areas to a few small shapes painted primarily with pure color or a few tints. Because you need colors that are both pure and light, you are restricted in your choice of color to those running from orange to yellow-green on the spectrum. I've used cadmium lemon, gamboge hue, cadmium orange, and phthalo yellow-green with only the slightest dilution.

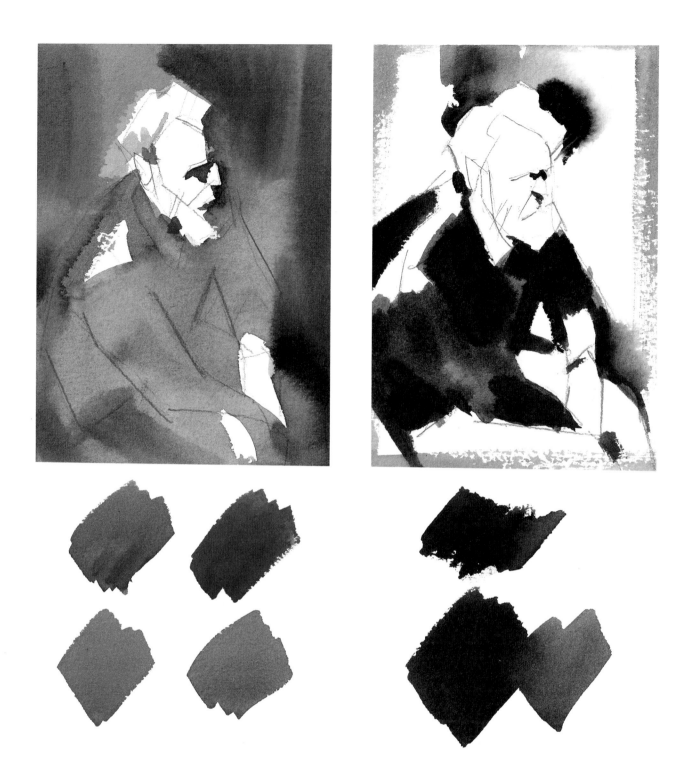

Middle values: To create the effect of strong lighting, move abruptly from your lights to mid-range values. These are usually shades, with perhaps a few muted tints in the transitional "half-light" areas. Here, I based my neutrals upon alizarin hue, phthalo green, gamboge hue, and French ultramarine.

Darks: Complete the painting with deep shades that contrast with the small areas of light color. You can use some black in very small amounts in the negative space that defines and contrasts with the light. My black is alizarin crimson plus phthalo green. I've also used black mixed with gamboge hue and French ultramarine.

Color Organization

European painters in the 16th and 17th centuries effectively depicted dark interiors illuminated by only a candle. To recreate their effects, keep yellows in your small light areas and surround them with large areas of deep and slightly cooler shades.

The lightest pure color you can use is a greenish yellow, such as Hansa, Winsor, or cadmium lemon yellow. Going slightly darker, you would use a warmer yellow, such as gamboge hue, cadmium yellow medium, or cadmium orange. You can include pure colors for your mid-range values—such as cadmium scarlet and cadmium red—but the greatest proportion of the painting should be in deep, warm shades. Rembrandt commonly used burnt umber for this purpose. To help relate a figure (or object) to its ground and to avoid making deep "holes" in your pictorial space, you should repeat some of the figure's warm hues in the surrounding space.

Again, black should be used as a local color; use it sparingly in areas of negative space. Many black pigments are available, but I prefer to make mine by combining phthalo green with alizarin crimson or red rose deep.

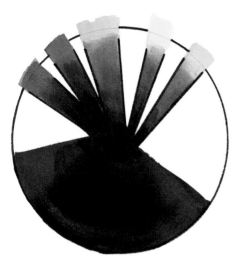

In this approach, shades that range from brown to deep blue and black (bottom of diagram) should dominate the picture. Your light, pure colors (shown here emerging from the darks) are confined to small areas and range in hue from yellow-green and yellow to orange and red-orange.

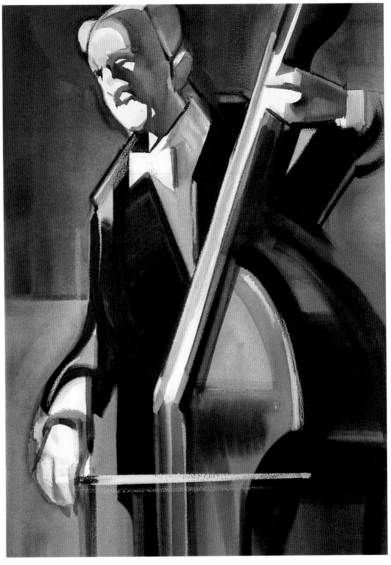

Christopher Schink
CONTRA-BASS
Watercolor on paper, 32 x 24" (81.3 x 61 cm)
Collection of Mr. and Mrs. William Cox, Palo Alto, California

Most people don't associate watercolor with deep shades and blacks, but I've found nothing on the labels of watercolor tubes warning against it. The effect of a "Rembrandt" approach can be dramatic. In this painting, I limited my lights to a few strategic areas. I used more color than usual in the shaded areas to enliven the figure.

"TURNER" COLOR

The "Turner" approach follows the uses of color and value explained below.

Joseph Mallord William Turner was, like Leonardo da Vinci and Rembrandt before him, one of the true geniuses of painting. His unique way with color was far in advance of the conventions of his time, and it was almost a century before his innovations were fully understood by color theorists. Turner actually used a variety of approaches throughout his career, but it was his use of neutral tints to set up subtle luminous effects that distinguished his work from that of his contemporaries. By starting with tints—not pure whites—and surrounding them with muted tints and grays, he created a subtle luminosity. (The same approach was later used by James Abbott McNeill Whistler and Edgar Degas for similar effects.)

Turner's works, then, convey a *quality* of light, rather than accurately recording local color or the effects of sunlight and shadow. Turner used colors that were for the most part subjective; for example, although he traveled throughout the lush landscapes of Europe, he rarely painted anything green. He was more interested in light and atmosphere than in the interaction of complements.

With the "Turner" approach, you exploit differences in color intensity. As we saw in the section on creating luminous effects (pages 99–106), your small areas of tints should be surrounded by muted tints and grays. Strong contrasts in value are avoided. And be particularly careful not to leave white paper visible in your picture. It will appear cold and raw.

Lights: In this approach, as in the previous two, you leave no areas of white on your paper. Paint your lightest values with tints of pure color, limiting them to small areas of importance. These are my tints, made from permanent rose, aureolin, cobalt blue, and phthalo green.

Middle values: Because you do not depend on value contrasts, you should surround your lights with only slightly darker muted tints and grays, and avoid the temptation to use strong darks. Here, I have neutralized permanent rose, aureolin, viridian, and cobalt blue with gray or complements.

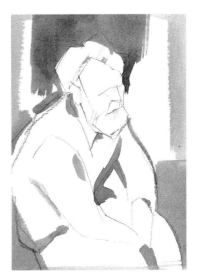

Darks: Whistler and Degas would occasionally use dark grays or black with this approach, but you can achieve greater luminosity if you keep your darkest areas at middle value. For my darks I muted phthalo green with alizarin crimson hue, adding cerulean blue and yellow ochre for opacity.

Color Organization

Normally, you paint the small areas of light tints in this approach with warm yellows, yellow-greens, pinks, and oranges, and you surround them with neutral colors. Although you are basing your color choices on differences in intensity, you can also use some contrasts in hue (for example, surrounding a tinted red with muted greens) to enhance your painting.

Turner liked to base his paintings on the differences in intensity between tints and more muted colors and grays. Here, I have tried to suggest a few warm tints, the diluted reds, orange-yellows, and lemon yellow on the outer circle, which you might play off of the cool neutrals on the inner circle. These, ranging from muted red-violets to gray-green, occupy a greater proportion of your image.

Judi Betts
MISS AMERICA
Watercolor on paper, 30 x 22"
(76.2 x 55.5 cm)

Betts does not rely on strong value contrasts or bright color to hold our attention in this painting. On the contrary, she surrounds lights, which are tints, with slightly darker muted tints and creates a convincing sense of luminosity.

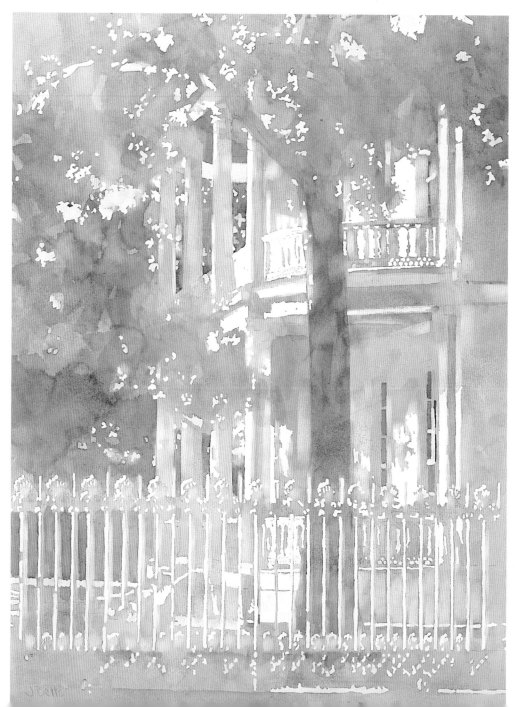

"IMPRESSIONIST" COLOR

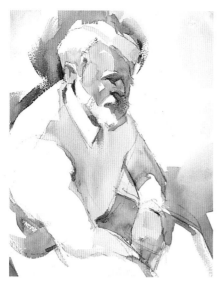

The Impressionist color approach resulted from a series of artistic, scientific, and technological developments: the influence of the 19th-century Romantic painter, Eugène Delacroix, who used pure color boldly; the discoveries of Eugène Chevreul; and finally, the availability of many new, intense paints sold in easily portable metal tubes. The Impressionists—including Monet and Pierre-Auguste Renoir—enjoyed the portability of the new paints; they could move from the studio to the outdoors and capture in paint the play of light and shadow in nature. They abandoned the somber neutrals, earth colors, and blacks conventionally used in landscape painting till then and turned to pure colors, tints, and whites—a palette ideally suited to watercolor.

You may have already used an Impressionist palette when painting a watercolor. Most painters have no trouble producing tints or leaving white paper. They do, however, often feel compelled to finish every painting with dark shades and deep blue-grays. But darks are kept to a minimum in this approach and serve primarily as accents to direct the viewer's eye. You should be especially careful not to use too many deep blues or blue-violets; in relation to the rest of the palette, they look *too* dark and receding.

The Impressionist approach will produce a vibrant painting if you avoid creating neutralized tints. I suggest you try mixing your colors on the paper as you paint, rather than on your palette, and adhere to the following guidelines.

This portrait painted in an Impressionist way employs the color and values explained below.

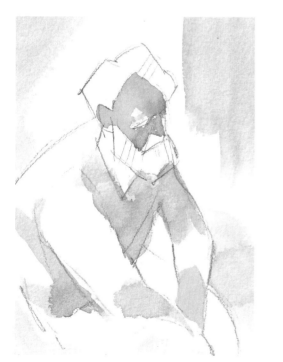

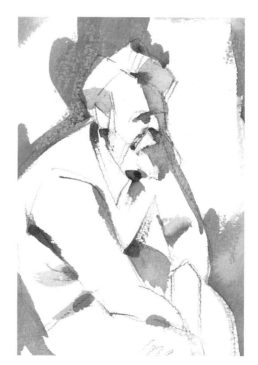

Lights: You begin your painting by carefully planning and leaving fairly large areas of white. For your first washes, you should use tints. My tints here are dilutions of cadmium lemon yellow, aureolin, permanent rose, cobalt blue, phthalo green, and phthalo blue.

Middle-value colors and darks: Work in the mid-range values with tints and pure color. For shadows, use cool tints such as a blue-violet, and avoid grays or muted color. Darks should be pure colors used as accents. Here, slightly diluted Winsor violet, phthalo green, cadmium scarlet, and gamboge hue are shown with accents of the same or contiguous colors.

Color Organization

A dominance of one color is not critical with the Impressionist approach. You create a sense of unity by using tints of pure color in light to middle-light values throughout the picture—in other words, by a repetition of values rather than of colors. Indeed, you can employ any or *all* tinted hues—tinted reds, oranges, yellows, violets—in the same painting and still achieve a harmonious effect. If you emphasize *warm against cool* relationships, rather than dark against light, and repeatedly juxtapose complementary or near-complementary colors in similar values, you can increase vibrancy.

In the same way, as Monet and Camille Pissarro became more aware of the effects of simultaneous contrast, they increasingly lightened their palettes and suggested sunlight and shadow using a range of tints. Warm tints predominated, except where they created atmospheric effects, and there they emphasized cools.

With this approach, you can employ any or all of the colors on this diagram throughout the painting and still achieve a harmonious effect. Note the absence of neutrals and shades here!

Anne Adams Robertson Massie

Crowd at
J.W. Woods
Watercolor on paper,
22 x 30"
(55.9 x 76.2 cm)

Massie has adopted an Impressionist palette—a predominance of white and very light tints throughout the painting, and skillfully placed accents of pure color to direct the viewer's eye through her composition.

"Tonalist" Color

The Tonalist palette employs the color and value choices explained here.

Color does not have to be bright or varied to be expressive. A few great artists have chosen to rely primarily on value contrasts, line, expressive brushwork, and surface texture to convey mood or express feelings. Contrasts of color play almost no part in their approach. They have become known as *Tonalists*, a term that refers not to their colors but to their manipulation of values. By working almost entirely in neutrals, shades, and grays and black, they created often somber and deeply felt works that evoke a strong emotional response from the viewer. El Greco, the late-Renaissance master, employed this approach to give some of his religious figures an eerie, almost supernatural feeling. Many contemporary abstract painters, such as Franz Kline, have used a similar palette to give their work emotional power.

Unlike all the other color approaches described in this survey, this one employs neutrals—not white or clean-looking tints of pure color—for the light values. In fact, these and the middle-range values are muted tints or even grays. You paint the darkest values with shades, deep grays, or blacks.

Unless you bring other elements such as surface texture into play, in a Tonalist approach you will be working with little more than a monochromatic arrangement of shapes. You can give your painting an initial coating with a wash of light, neutral color, with grayed gesso, or even with charcoal rubbed into the surface. An active, textural surface quality can be an integral part of this approach, so don't be too neat or fussy. A drybrush technique in the transitions between light and shadow areas also lends texture.

Lights: Muted tints serve as the lights in this approach. Here, yellow ochre, Winsor violet, and lamp black were diluted and neutralized. Note the use of charcoal and watercolor crayon to give surface texture.

Middle-range values: Here, you use darker grays and muted tints. You can make your muted colors by combining complements or adding gray to a pure color tint. Here, I made several brownish neutrals, a gray, and olive green my middle values.

Darks: Your darkest values should be shades, deep grays, or blacks. The usual procedure in watercolor is to paint these last and place them judiciously, but you might find it easier to paint your darkest areas early to help you judge value relationships.

Color Organization

In this approach you'll find the distribution of color over the surface less important than the arrangement of values. But color-temperature shifts, the interplay of warm against cool, will enhance your painting. You can use warm colors on your figures or dominant shapes and surround them with a predominantly cool ground, creating volume. For a flatter, more contemporary painting, you would reduce this contrast in color temperature or, in some cases, reverse the relationship: cool shapes, warm ground.

The muted tints and shades of this color diagram are dominant in this approach. The muted oranges and reds serve for the warm shapes that you surround with the more neutral, cooler shades and grays. Here, they are mixed from violets and blue-greens.

Dean Mitchell
MR. EARNEST'S PECAN SHOP
Watercolor on paper, 22 x 30" (55.9 x 72.6 cm)

In this thoughtful arrangement of shape and value, Mitchell restricts his palette almost entirely to off-whites, grays, and blacks. Even muted color is kept to a minimum. He uses surface texture and detail to relieve the monotony of the large light shapes. His Tonalist color reinforces the feeling of rural antiquity.

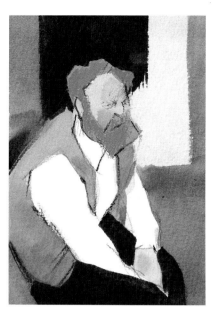

A variation on the Tonalist approach: Contemporary painters often use arrangements of white, black, gray, and pure color (such as this cadmium orange). Note the progression of white to gray to black (illustrated in the rectangle), which is a more pleasing order than a sequence with juxtaposed extremes—say, white against black surrounded by gray.

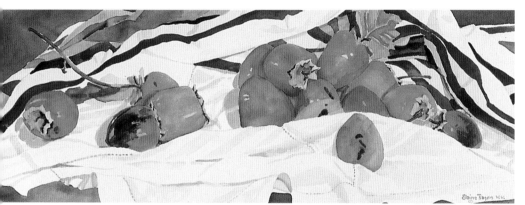

Elaine Rogers
STILL LIFE WITH PERSIMMONS IV
Watercolor on paper, 22 x 30"
(55.9 x 72.6 cm)

Rogers based the color scheme of this still life on arrangements of pure color (orange and blue), white, warm and cool grays, and small touches of black. Her use of this variation on Tonalist color and her emphasis on shapes give a solid, classical quality to the painting.

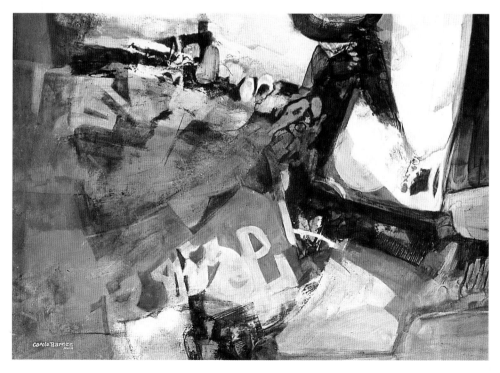

Carole Barnes
ANCIENT SYMBOLS WITH BLUE
Acrylic with collage on paper,
22 x 30" (55.9 x 72.6 cm)

Barnes varies the Tonalist palette in this painting, adding pure color to white and black. (Note how, to maintain a flattened picture plane, she alternately overlaps her black and white shapes.)

"POST-IMPRESSIONIST" COLOR

After Impressionism had become a pervasive influence in the art world, painters such as van Gogh and Gauguin began to use color in a more personally expressive way than had been practiced by anyone before. They used color to describe not just what they saw but how they felt about what they saw. These Post-Impressionists were innovative colorists who, aware of the theories of the Impressionists, experimented with new ways to use color, form, and pictorial space. Van Gogh, especially, expanded the color vocabulary of the Impressionists to create highly emotional works of art. Less interested in accurately recording the effects of atmosphere and light, as Monet and Pissarro had been, he juxtaposed colors in novel ways.

Let's examine how you can organize color using the Post-Impressionist approach.

This portrait done in a Post-Impressionist way employs the color and value selections explained below.

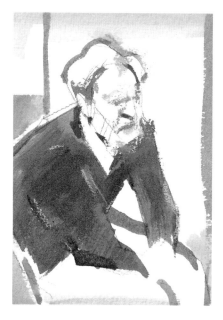

Lights: Instead of whites or lots of tints, your lights should be restricted to just a few tints and the lighter-valued pure colors. Here, with slight dilution, I used cadmium lemon yellow, gamboge hue, cadmium orange, and permanent rose for my warms, and phthalo yellow-green, Winsor violet, and cobalt blue for the cooler colors.

Middle values and darks: Use middle-range pure colors such as phthalo green, Winsor red, and cadmium scarlet. These are employed in flat patterns rather than for shading. Darker pure colors, like the Winsor violet here, are used in small touches to define forms, not for interior shadows.

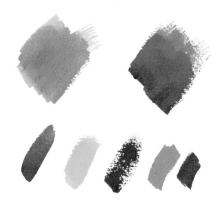

You'll find this approach harder to use in watercolor, in which you often build from light values to dark. Contrary to the usual practice of diluting your colors with water, you apply them almost straight from the tube. Using maximum color contrasts, your major concern becomes the interplay of complements more than value relationships. When you juxtapose dissimilar color areas in watercolor, you can often get a muddy, gray puddle. You do not want to leave white borders or gaps between them, so you must work very carefully.

By using some opaque additions (acrylic, casein, gouache, or crayon) for repairs and to add small touches of bright color, you can create a vibrant painting very different from the typical watercolor.

Color Organization

To express his intense reaction to his subjects, van Gogh used strong contrasts of pure complementary color—red against green, yellow against violet—in combinations that even his friend Gauguin found disturbing. Later, the Fauvist circle, which included the young Matisse, began to use pure color in ways that had little or nothing to do with their subjects' local colors—purple trees with green skies and orange water!

To say the least, color organization using this approach calls for thoughtful choices. If you use four or five pure colors in equal amounts throughout the painting, you will have a can of worms. Instead, create a sense of unity by setting up a predominance of contiguous and similar colors. Then, with a lesser use of complements, establish some contrasts.

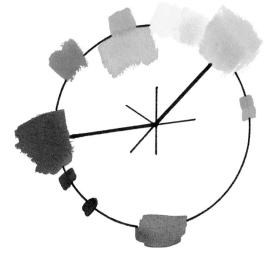

Using a simple complementary contrast, you would put, let us say, a lot of red next to a little green. With a split-complementary contrast, you would juxtapose a lot of red with two greens, such as yellow-green and blue-green, as this diagram illustrates (that is, the complementary splits in two). Both ways of using colors that are opposite on the color wheel are easy aids to organizing color in this approach.

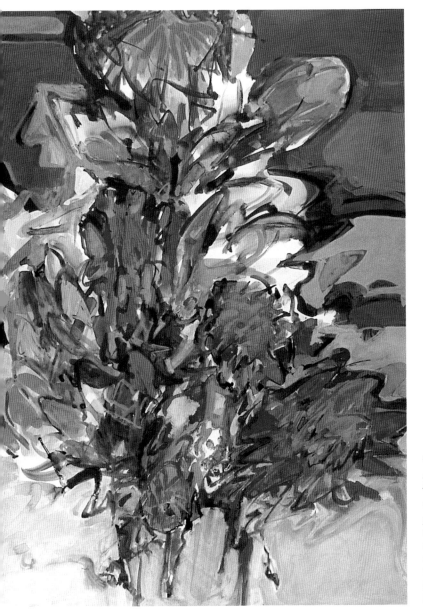

Carol Tolin
ANNIVERSARY PROTEA
Acrylic on paper, 24 x 23" (61 x 58.2 cm)

Complementary colors and strong brushstrokes give this painting an intensity not usually associated with florals. With transparent watercolor you can easily produce dark, muddy areas where you abut or overlap complements. You'll find using an opaque medium a help in these critical areas. Here, Tolin used acrylics in both transparent and opaque applications.

"Bonnard" Color

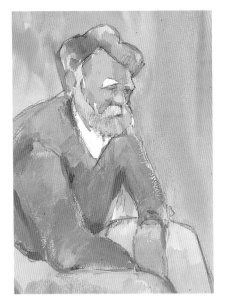

The early modern painter Pierre Bonnard employed the Impressionist palette in a personal and intuitive way. His uses of color and simultaneous contrast were similar to those of the Impressionists and of van Gogh, but his approach and objectives were really quite different. By constantly alternating complementary tints and pure colors in small touches that were very similar in value, he created a highly original style.

Bonnard often worked with awkward compositions, developing color relationships with little regard for the accurate depiction of light or form. Like many artists of his day, he admired the flat patterns of Japanese prints, and his narrow value ranges were consistent with flattening of pictorial space.

This concept may work better for you in oils or acrylics than in transparent watercolor, where small touches of complementary color running together produce an unwanted gray. Here, though, are a brief explanation and some watercolor guidelines.

This portrait done with a "Bonnard" approach employs the color and value choices explained here.

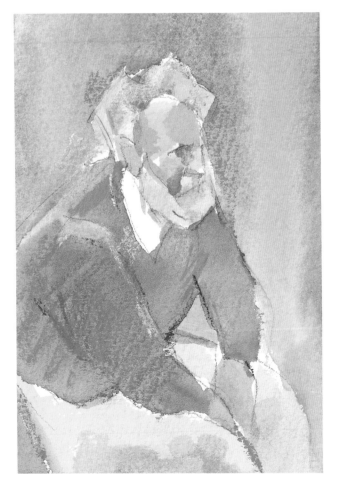

Lights, middle values, and darks: You use little white in this approach; instead, you paint your lightest values with the light, pure colors and with tints. Keep the values similar on forms—forget about describing light and shade. For my light, pure colors here, I used cadmium lemon yellow, gamboge hue, and cadmium orange. I slightly diluted permanent rose, cobalt violet, cobalt blue, and phthalo green.

You should paint the mid-range values with pure colors. Some of these may be tints of the darker pure colors such as violet and blue. But, again, avoid strong light-and-dark shifts within forms and limit darks to just a spot here and there.

Color Organization

Wherever possible, you want to emphasize small touches of contrasting colors in this approach. You employ almost the same palette as in the Impressionist approach, but there are some subtle differences—less reliance on white and less concern with modeling forms with lights and darks. Here you use primarily tints and pure color in complementary and near-complementary arrangements that are *similar in value* in order to achieve the maximum color interaction. (Remember: The interaction of complements is greatest when the colors are similar in value.)

The "Bonnard" approach involves using a wide range of the pure colors on the color wheel. You can use all of these and not create disturbing discords if you keep them light and avoid value contrasts.

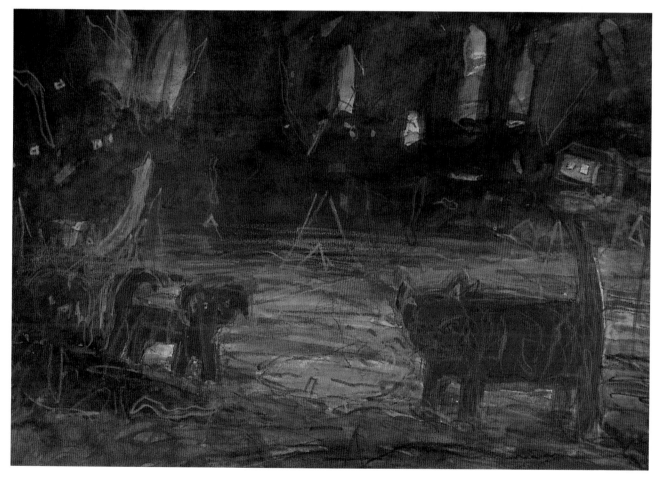

Kathleen Kuchar
PINK PETS
Watercolor on paper, 9¾ x 14" (24.8 x 35.5 cm)
Collection of Gail Gutierrez, Silver Spring, Maryland

Using a fundamentally "Bonnard" approach, Kuchar alternates pure colors that are limited to mid-range values. Pervasive reds, red-oranges, and magenta interact vibrantly with the green, red's complement. She does use some areas of darker value for the expressiveness of color, not to create shadows or to model forms.

"MATISSE" COLOR

Shortly after the turn of the century, the young Matisse and his circle, known as the Fauvists ("wild beasts"), adopted van Gogh's seemingly arbitrary uses of color and took them even further. Matisse himself briefly experimented with the Neo-Impressionism of Paul Signac and with Fauvist ideas and then abandoned *all* color theories to work in an largely intuitive way. Relying on his keen perception of color interactions, he worked in combinations of pure colors, tints, and (occasionally) muted colors and black.

Matisse's approach to color, then, was unique; he simply reacted to what he saw. As he introduced a new color into his painting, he modified previously painted areas, constantly changing color and shape relationships however he wished. As this freedom implies, a full spectrum palette, as well as black and white, can be used for this approach.

To emphasize the arrangement of color in flat shapes, in this approach pictorial space and the modeling of forms with light and dark contrasts are kept to a minimum. Color areas are inventively arranged and often boldly abutted. Therefore, as pointed out in the "Post-Impressionist" and "Bonnard" approaches, unless you rely on some opaque touches, you may find it difficult to use this approach working in transparent watercolor.

This portrait done in a "Matisse" approach employs the values and color examined below.

Lights, middle values, and darks: To achieve the maximum color interaction, stick to lights consisting of pure colors, and avoid value shifts within forms. You employ mostly pure color in the middle values and darks also. (Shaded darks seem out of tune in this approach.) Only slightly diluted, my pure colors here are Hansa yellow, permanent rose, Winsor violet, viridian, and cadmium orange.

Color Organization

Matisse often used colors widely spread across the spectrum. So little did one color dominate that his color schemes teeter on the edge of disunity. No color diagram would serve as a key to his approach.

In addition to the rampant color, black can used in this approach as a local color, in both figure and ground. A line of black (or of pure color) can separate areas that are different in color but close in value (see portrait, opposite).

If you use this approach, you'll have to rely on your instinct and eye—and your ability to accept some failures!

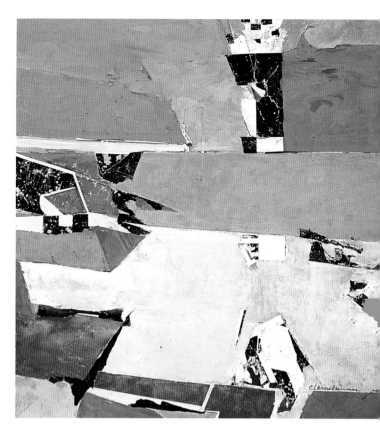

Charles Winebrenner
TOP VIEW
Acrylic on paper, 24 x 24" (61 x 61 cm)

Composing with a wide range of pure color isn't easy, but Winebrenner uses orange, green, blue, violet, red, and yellow in this painting and makes it work. He uses small areas of black and white as local colors on shapes or on the edges of shapes. Even with a keen eye for color relationships, you'll find this "Matisse" approach calls for many revisions as you work.

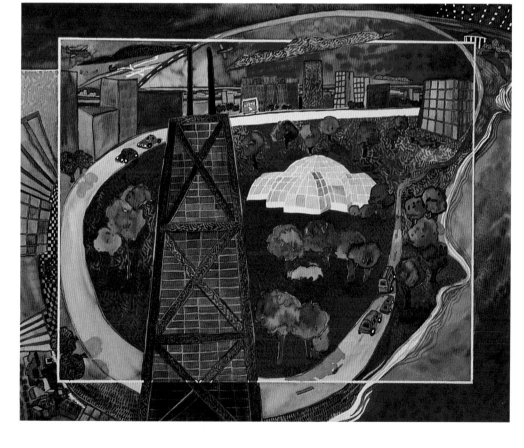

Fran Larsen
A DRIVE THROUGH LINCOLN PARK
Watercolor on paper, 20 x 24" (50.8 x 61 cm)

Larsen uses a predominance of pure color in lively combinations and whites, grays, and blacks as flat or linear elements (not as a means to model form). Like Matisse, she keeps the pictorial space flat and organizes her color in patterns.

5 COLOR AND EXPRESSION

I learned that you had to have a good reason for using one color rather than another. . . . I met a lot of nice colors.

ROBERT RAUSCHENBERG

Reading this book will not make you more creative. No instructor, class, or book can teach you how to be original, imaginative, or even sincere. My objective in this book is to help you expand your color vocabulary and become more aware of how to compose a coherent design. Finding a personal and original form of expression is entirely up to you.

In this section I include the work of nine accomplished artists along with their thoughts on color. I conclude with some considerations to help you choose your own color approach.

I invited artists whose work I admire to contribute examples of their paintings. I included these particular artists not because their work represents some unique use of *color* (although all are superb colorists) but because their work is distinctively their own. Each artist approaches color differently. For some it is a primary and consistent element in their work; for others it plays a secondary role. But all employ color in a thoughtful and personal way.

None of these painters fits the uninformed public's image of an artist: an idiot savant who has only to wave a brush to produce a work of genius. They are *all* knowledgeable in theory and conscientious and skillful in their craft. In short, before they came to "feel it," they *knew* it.

Personally, I am fascinated with color— what you can do with it and what it does for the expressive qualities of a painting. But I don't consider myself a natural colorist; rather, I'm a student of color, an experimenter, an analyst. However, I run the risk, as do all painters who also teach, of producing works that are more didactic than heartfelt, more calculated than creative. For that reason, I try to take an intuitive approach to color, allowing instinct rather than intellect to guide me. There is a danger in this when working in transparent watercolor, and I find myself relying more and more on opaque media for additions and alterations when my intuition has led me astray.

The most consistent element in my work is the use of simple, geometric shapes to describe my subjects. These shapes are what I hang my color on. I plan my color only in the most general terms—warm or cool, intense or neutral, wide in value range or narrow—whatever seems to fit my initial reaction to my subject. I think of predominance and contrast in the simplest terms: a lot of this and a little of that.

To avoid repetition, I sometimes start my painting with a color I am unfamiliar with or use infrequently. I can't visualize or predict the results, and for that reason I may repaint a design several times, exploring new color possibilities until I achieve a satisfying result. I don't find this process discouraging or frustrating; I find it fascinating.

EDWARD BETTS
KENNEBUNK, MAINE

In their initial stages, most of my paintings develop improvisationally and depend to a great extent on intuitive procedures, so it is appropriate that my color relationships are usually arrived at intuitively. Over the years, attention to theories of color has not been as helpful to me as simple trial and error—assessing which color relationships work and which do not. Rules are, of course, necessary guides when we first learn our craft, but frustration is bound to set in whenever the principles of color do not apply to specific problems in the picture at hand. My reliance on intuition has come about partly as

an extension of the picture-forming process itself and partly because long experience has encouraged me to try out my own color ideas unrestricted by mindless adherence to rules. In recent years, I have achieved the ability to sense, to imagine with surprising accuracy, precisely what color would be most effective in a particular placement on the picture surface. This phase of mental visualization before settling on color choices virtually eliminates trial and error and generally leads me to a more intriguing, unexpected, and unpredictable use of color throughout the picture.

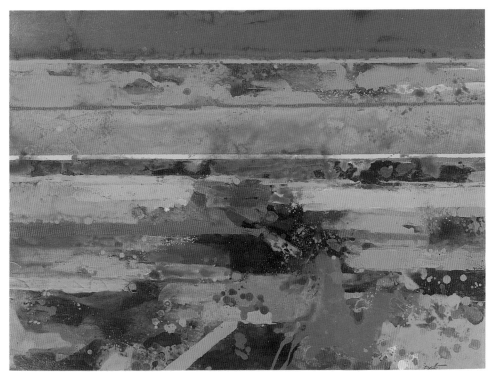

Edward Betts
TIDEMARKS
Acrylic on fiber board, 30 x 40"
(76.2 x 101.6 cm)

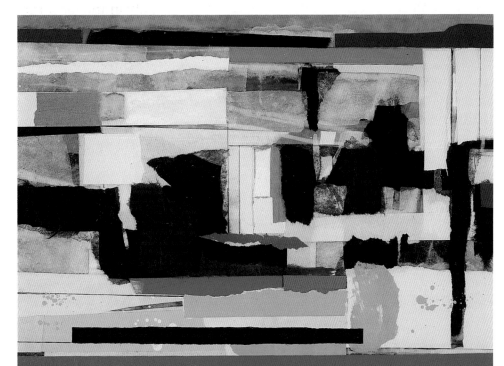

Edward Betts
QUARRY IN WINTER
Acrylic and collage on illustration
board, 11 x 14" (28 x 35.5 cm)
Collection of the artist

GLENN BRADSHAW
McNAUGHTON, WISCONSIN

My paintings begin improvisation-
ally and are developed directly on
the paper without benefit of prior
sketches. I may begin with splashes
of color, linear marks that I think of
as edges for shapes, or gestural marks
made with large brushes. Whatever
approach I use, my concern from
start to completion is the total page,
and my initial paint application is an
attempt to create a rough skeleton
for the finished painting. I may or
may not have a theme in mind, but I
never have an "in-mind view" of
what I am painting. The painting
evolves through applications of thin
layers of diluted casein paint to both
sides of Japanese rice paper. I strive
to make a complex orchestration of
color and form the result.

I work intuitively. I resolve
relationships within each work so
that there is a balance between the
various elements, and to do so, I rely
on feelings rather than rules. If it
seems "right," I assume it is right for
the moment, although all decisions
are subject to review and change as
the painting progresses.

Nature in some form is my
inspiration, even though the original
reference may not be evident in the
finished work. My goal is always to
create a visual experience which is
complex enough to be shared with
the viewer over repeated viewings.

There are no profound messages
or literary aspects in my work. They
are, I hope, visual adventures to be
enjoyed visually.

Glenn Bradshaw
SINGLE AGATE I
Casein on rice paper, 19 x 25" (48.2 x 63.5 cm)

Glenn Bradshaw
ELEMENTS
Casein on rice paper,
24 x 24" (61 x 61 cm)

Oscar (Buddy) Folk
GREENVILLE, SOUTH CAROLINA

I am not much good at "artspeak," and I find it impossible to describe the creative process of painting with words. Art is the only real thing that language cannot express. Image-making and language came into being at the same time and both were produced by the mind, but language and art are like parallel lines: They'll never meet. That it is impossible to describe color to a blind person is only a half-truth, for it cannot be described at all, period. But it doesn't matter that it can't be done, for it isn't necessary. Here are my paintings—the titles of which have been made up by others.

Oscar (Buddy) Folk
DIMINUENDO IN BLUE
Watercolor on paper,
22 x 30" (55.9 x 76.2 cm)

Oscar (Buddy) Folk
JAZZ QUARTET
Watercolor and oil pastel on paper,
22 x 30"
(55.9 x 76.2 cm)
Private collection

FRAN LARSEN
SANTA FE, NEW MEXICO

For years, I have been increasing my knowledge and use of color as another tool to reinforce yet again the design aspects of my painting. When I begin a painting, I do not have a color plan. I don't pick a scheme. I just put some color on paper.

It took me a while to understand that all color does is attract the eye to the painting. Color can make my eye move around the paper in various ways; it can push me and pull me; it can be repeated or contrasted or isolated. As I painted with all the colors, I learned that the less white in the painting, the more color my eye saw as *color*. I understood that the first thing a baby sees is light and dark, and the last thing a person going blind loses is the ability to distinguish light and dark.

We call light versus dark *value*. I started to take more and more of the value contrasts out of my paintings, to stay with color only. One day I began to see that even the white mat on a framed watercolor caused too much visual contrast for the viewer to get maximum color sensation. So I began to paint the mat and frame as part of the painting. If I wanted color to do its job for me, I had to give it every chance.

When I start a painting today, I don't even consciously pick a color. Any color will do—I use them all. Sometimes I wish there were even more. I put my

brush on the palette, get some color, and make a shape—and then another and another. It is like weaving a tapestry of shapes and colors, each shape and color suggesting another. I respond to each color, I have a conversation with each shape by putting a color next to it that directs my eye toward the area of the painting I want to be seen most. I use contrasts in intensity more than contrasts in value (bright versus dull, rather than light versus dark). When I finish covering my paper with color, I begin to modify sections with glazes of complementary color to tone them down, reinforcing where the emphasis of the painting is to be. Suddenly, without my knowing in advance, the shapes will seem in balance. My eye will be attracted and moved through the painting in a satisfying way. The painting will have a glow and inner life.

Over the thirty years I have been painting in watercolor, I have learned lots of color theory, design theory, and assorted techniques and technical information. In the end, it boils down to choosing the best lightfast pigments available; squeezing out big blobs of it on my palette; getting an idea I want to express; and having a conversation with shape and color. My advice to students of color is to use lots of it every day. Learn for yourself how it moves the eye, and just keep painting.

Fran Larsen
DESERT DANCE
Watercolor on paper (with painted frame), image size:
20 x 24" (50.8 x 61 cm)

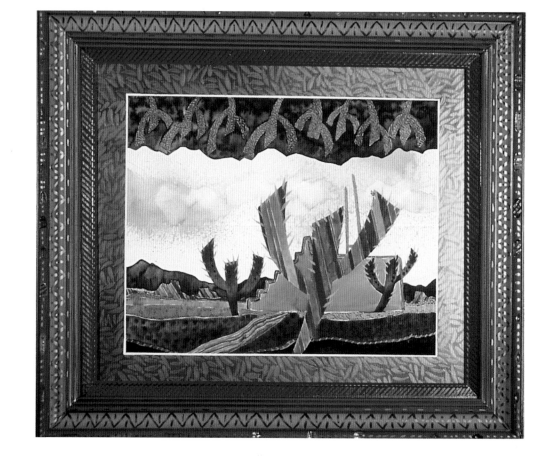

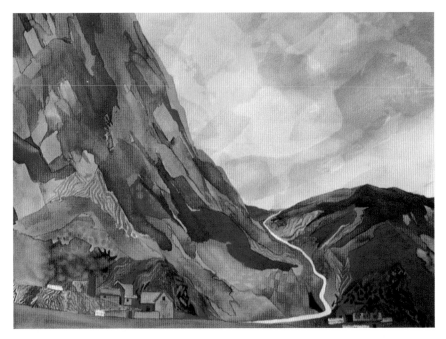

Fran Larsen
THE ROAD PAST
Watercolor on paper, 22 x
30" (55.9 x 76.2 cm)

Fran Larsen
ROADS ALONG
THE RIVER
Watercolor on paper, 36 x 24"
(91.4 x 61cm)

Color and Expression **131**

WILLIAM (SKIP) LAWRENCE
MOUNT AIRY, MARYLAND

I facetiously told Mr. Schink that the opening statement on color in my own recently published book was: "Color is good; take red, for example." While this sounds ridiculously simple, it is not far from the truth. As a representational painter who spends hours looking at a subject, I think slavishly matching local color is the last thing I want to do. Rather, I look for those "color clues" that both express my feelings for the subject and provide an excuse to paint. In an entire landscape, there may be one small color relationship which will inspire the entire color harmony for a painting. The orange slicker of a fisherman, a streak of yellow across a shadowed road, or the perception of deep blue sky is all I require to begin a painting.

Color is both simple and complex. To master the endless color possibilities is, in fact, impossible. On the other hand, color relationships are rather limited. A color is selected and placed on the paper. The next color is related to the first: if lighter, it makes the first seem darker; if darker, the first appears lighter; if cooler, the first looks warmer; if neutral, the first looks brighter, and so on. I was not blessed with perfect pitch in music or in art. Hence, I must continually refine color relationships through a process of trial and error. I actually find this process the most rewarding and exciting part of painting. When I finally find that perfect chord of color harmony, nothing is more beautiful.

For me, color is the most essential element of painting. I have never been completely satisfied with a painting unless I was happy with its color. Color is the most evocative and expressive element in our vocabulary. To ignore color is like humming while others are singing.

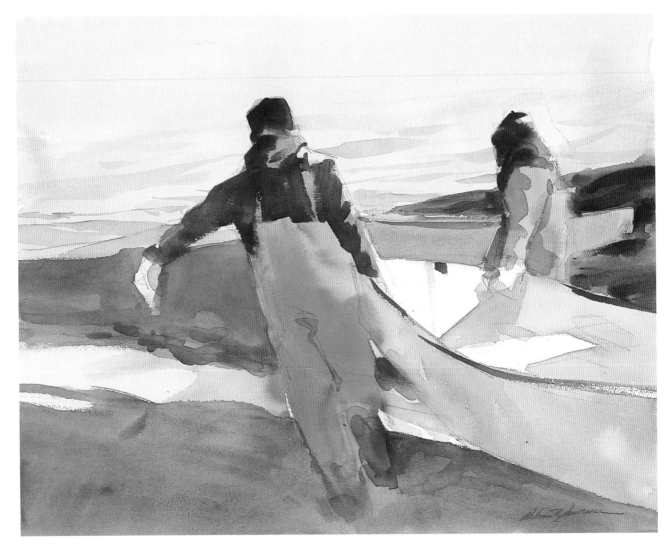

William (Skip) Lawrence
PULLING TOGETHER
Watercolor on paper, 20 x 26" (50.8 x 66 cm)
Collection of the artist

KATHERINE CHANG LIU
WESTLAKE VILLAGE, CALIFORNIA

Color is an element of *design* that has taken me some time to figure out. In my recent work, I have chosen to work with a rather limited palette. Initially, this was a choice I made to minimize the options of form, to allow me to concentrate on the expressive content of each painting. Although this decision did help me with focusing my work, I realized that design is still a necessary consideration in resolving a painting. Without a thorough knowledge of the elements of form and design, I would have difficulty in delivering the content.

In looking back, I realized that while I used quite a variety of colors early on, my attitude toward them was

like that of a kid in a candy store. Sometimes curiosity guided my selections more than any coherent knowledge or reason. At other times I chose colors because they "looked good" together, without having much understanding of the dynamics between the colors. Eventually this attitude led me toward what I see now as a rather weak body of work. I suspect this was a process of learning by elimination. We all acquire a working preference for colors, and I believe our selection of colors is every bit as personal as our choice of content.

The palette I have chosen to use today might appear at first glance to be a nonpalette. It contains none of the

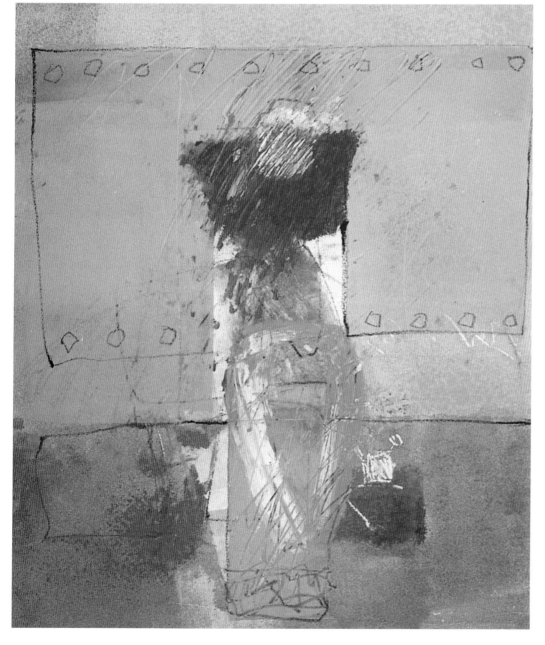

Katherine Chang Liu
WALL MARKS #42
Monotype on paper,
14 x 12" (35.5 x 30.4 cm)
Private collection

bright colors. It is made up mostly of tints, neutrals, and grays. My primary considerations are now in the use of color to create patinas and implied "visual histories" on my painting surface. When I eliminated the many bright colors from my work, the subtleties and evocative qualities became more evident and more important. At this point, I believe this approach is best suited to the content I am trying to convey.

My painting process is one of building up and tearing down, and oftentimes hidden between layers are suggestions of strong color. This provides needed interest to the muted tonal field of the painting. Intense and pure colors, when used, are used with restraint. As the painting progresses, I ask myself whether a color has been chosen to strengthen the work or merely decorate the surface. I prefer to create excitement by contrasting the subtle transitions of hue with abrupt changes in value, using my limited tonal palette along with strong darks and lights. I would like to be able to make a painting which can speak volumes through its nuances.

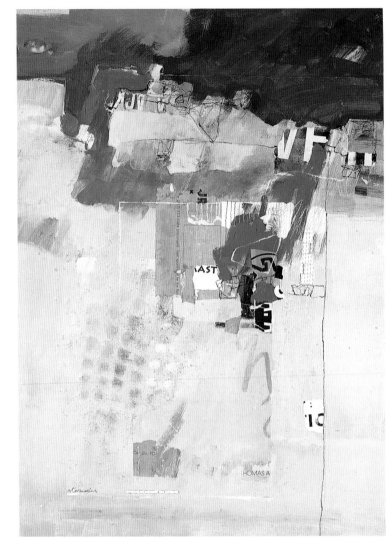

Katherine Chang Liu
VISCERAL MAP #2
Mixed media on paper,
35 x 25½" (89 x 64.8 cm)
Courtesy of Sandra Walters
and Associates, Hong Kong

Katherine Chang Liu
SCROLL #2
Mixed media on paper,
30 x 40" (76.2 x 101.6 cm)
Courtesy Horwitch Newman
Galleries, Los Angeles, California

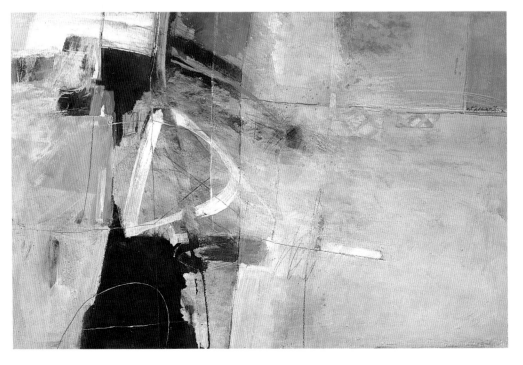

CAROLYN LORD
LIVERMORE, CALIFORNIA

To be a colorist isn't just to be indiscriminately colorful, but to express a mastery of color mixing, selection, and interpretation. It is to mix all the colors that are in your painting from a palette that has a full range of vivid, pure hues. I am pleased with the colors on my palette; they give me the capacity to mix and express color regardless of the subject: still life, floral, portrait, and landscape. I can mix vibrant brights and muted neutrals. I can apply the paint in an effortless sweep of color; or allow it to granulate into the pores of the paper; or apply it in nearly gouache-like opacity.

When I was in college, I believed that to achieve colorful paintings you must apply paint that is as saturated as possible, straight from the tube onto the paper. A summer watercolor workshop with Robert E. Wood, followed by a college course in oil painting, changed the misconceptions I had about mixing and applying color.

"Relationships" was the key word that artist Millard Sheets used in discussing color. Each color shape is judged in relationship to what it is next to: How bright or muted, light or dark, transparent or opaque is the

shape of color? A colorist works within the color-chord of a specific painting to create a unique relationship that expresses the artist's thoughts.

I don't leave white paper in my watercolors but paint my lightest areas a soft blush of a color that, compared to white paper, looks too dark. I know from experience that as I continue the painting with darker values and more intense colors that soft blush will appear white in relationship to them. To leave raw paper as the white does not create the effect or feeling I want.

I respond to unusual color relationships, or combinations, as presented by the visual world. The colors need not be harmonious or bland in their relationship to each other; it is the irregular and seemingly discordant colors that reveal beauty. When painting, I will accentuate subtle color perceptions to "push" and "pull" the composition and subject. I can develop a hierarchy of subject matter importance within a painting by shifting colors and values to push apart or to cluster together. It is with color that I am able to control the design and expressive qualities in a painting.

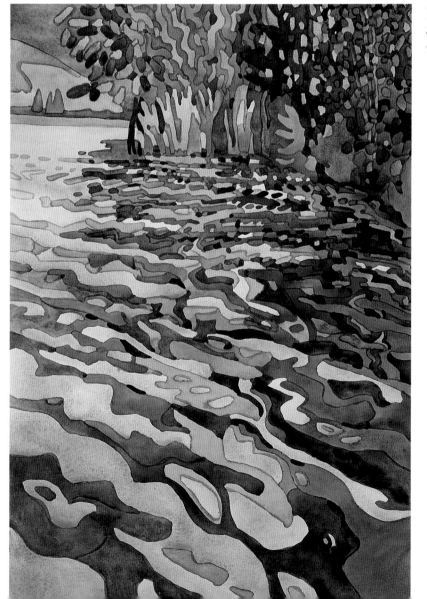

Carolyn Lord
POMERIGGIO D'ESTATE
Watercolor on paper, 22 x 15"
(55.9 x 38.1 cm)

ALEX POWERS
MYRTLE BEACH, SOUTH CAROLINA

Although my first two art teachers were colorists, I realized very early on that color would not be a dominant element in my painting. My feelings for and interest in color are far more negative than positive. For example, if I had to paint red against green for the rest of my life, I'd quit painting. Others might find the red of a rose beautiful. To me it is simply a middle value. I see and think in values. Rich darks contrasting with lights and grays are beautiful to me.

I do enjoy color accents—minor color notes in a dominantly tonal approach—such as I used in my painting *Kennedy*. The orange figure at the lower right is repeated in the top view of the flag-covered casket and at the edge of the television screen. Nevertheless, the painting is built on darks and lights.

Some symbolic color may appear in my paintings without my being aware of it: for example, a recurring red, white, and blue in paintings I have done on patriotic American war themes. My use of symbolic color is entirely intuitive.

Artists who were trained traditionally, as I was, must always deal with the issue of copying subject matter. Photorealists and traditional realists make a choice in favor of the local color of their subjects. I fight it, and I am glad I have fought it all these years. My work is about the transition of realistic images into abstract and undefined areas. Copying local color does not fit my aesthetic intentions, so I change many of the colors I see. I use arbitrary colors and local colors changed to values that will reinforce my expressive purpose.

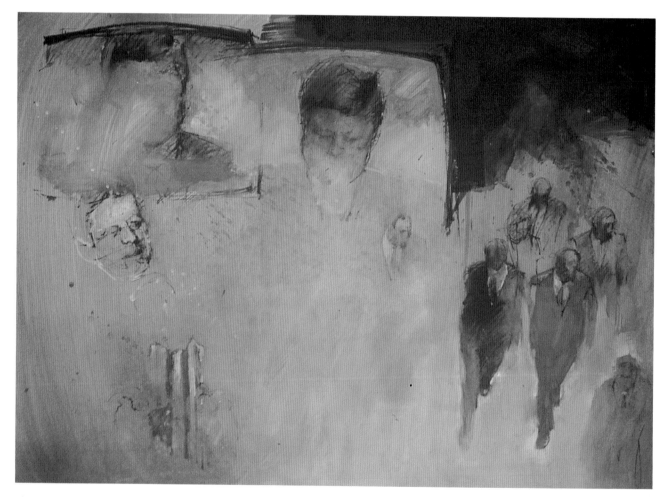

Alex Powers
KENNEDY
Watercolor, gouache, and charcoal on paper,
30 x 40" (76.2 x 101.6 cm)
Collection of Barbara Hall, Sun Lake, Arizona

EDWARD REEP
BAKERSFIELD, CALIFORNIA

When I first learned that colors might be deemed warm or cool—that color temperature existed—and that I could enhance a warm hue and make it appear warmer by abutting a cool color (or vice versa), and that a hot, golden sunset cast a cool shadow, my mind raced. Later, I became equally enamored with the proposition that by employing colors of equal value, my images would become essentially reliant upon the juxtaposition of colors.

In my unrelenting search for change, my efforts began to flop about, spurred on at times by some new color theory or structural idea. I began to purposely employ extreme color contrasts for more drama, or I'd limit my palette to clear darks or high-key lights. For more decorative work, I turned to bright, flat passages or to underpainting with complementary colors or neutrals. Glazing and scumbling had been around for centuries, but I wanted a more spontaneous result. One such approach which captivated me, and still does, is to lay in color in masses within perimeters that I delineate by bright lines of opposite colors—this is to intensify and illuminate the subject.

The time arrived when I paid little or no attention to such formal approaches, except to limit my palette at the outset of a painting. Recognizing that all color is no color, and understanding the psychological, symbolic, and spiritual significances of color (to name but a few), I began to rely more and more upon my intuition. This was consistent with an earlier abandonment of meticulously planned thumbnail sketches, often in color.

Once I produced a group of large, colorful paintings entitled "Phenomenological Color Series." I'm not convinced that the results lived up to that imposing title, but my massive patterns of tantalizing colors with myriad borders of iridescent colors were as satisfying as any work I've ever produced. We are well aware of the worlds of gamma rays and X-rays, worlds indescribably spectacular but invisible to the naked eye. Simultaneously, we recognize the limitations facing artists at work with mere paint, which is subtractive in nature. However, until our eyes can perceive those now-invisible phenomena, the knowledge and adroit use of color in combination with the majestic stillness of painting will remain for me a nonpareil.

Edward Reep
REQUIEM FOR REASON #2
Watercolor on paper, 29 x 43" (73.6 x 109.2 cm)

E. J. VELARDI
NORTHRIDGE, CALIFORNIA

There is no magic about color, in my view. What an artist does with packaged pigments is another matter. Orange is a hue; blue is a hue. But a muted, light orange-yellow might be a color or a gray, and a dark blue-violet might be a color, when in place in a painting. (Color characteristics are relative.)

I have never had a natural color instinct. Whatever sensibility I am aware of now is the result of a long period of study, when written notes, color schemes, color theories, and analyses of modern paintings substituted for my indecisive color inclinations. In time, the habitual use of notations, schematics, and theoretical references grew deeply rooted in my consciousness, and a disciplined spontaneity came to me as a reward and a convenience.

I am a draftsman more than a painter, relying on lines, distinct edges, and value relationships to form images. I am aware of the emotional and symbolic dimensions of color that are culturally imbued, but as options these dimensions offer me nothing essential to my expressive needs. Value changes, to clarify shapes, and synthetic surface variations, to counter visual monotony, are basic elements in my paintings. But the truth is that color is a constant worry.

At different times, I find colors to be visually distracting, inappropriately festive, or easily misleading. They should not compete with artistic individuality or with imagination and invention, so I favor colors that are descriptive or theoretically related. I avoid those that appear sentimental or decorative in character. For that reason, I suppose, nature's colors have not inspired me. My inspiration is art and a continuing evaluation of visual sensory experience. It is possible that this constant assessment has caused my color choices to change with time. What I once considered appropriate choices I now find obvious or immature. What was once unacceptable to me begins to have quality and "no-nonsense" attributes. What changed, more than likely, were my perceptions and my attitude. Certainly, one must account for the magic of artistic individuality.

E. J. Velardi
THERE ARE TIMES WHEN. . . .
Egg tempera on board, 30 x 36" (76.2 x 91.4 cm)

E. J. Velardi
1 OF 2 PARTS
Egg tempera on board, 30 x 36" (76.2 x 91.4 cm)

FINDING YOUR OWN COLOR STYLE

A van Gogh painting does not look like a Gauguin, nor a Rembrandt like a Turner. These artists approached color differently not because they thought having distinctive color might help them get into their local art societies or sell more paintings, but because they felt and thought individually about what they saw and wished to paint. That their paintings continue to speak to us today bears witness to the clarity and depth with which they put across their message. In short, what they had to say determined the way they said it—the colors and approaches they used.

If you've studied this book, you are aware that there are as many different ways to use color as there are artists. Although each artist represented in these pages has a distinctive approach, I doubt that any of the artists consciously sought just to be different. If even one had done so, we'd sense it; the paintings would seem superficial and merely stylish, lacking in emotional involvement and content.

One of the hardest things for a beginning painter to do is determine what expressive quality he or she wants to convey in a painting. As beginners, particularly in watercolor, we're involved primarily in the craft of painting and are content to show people we can do it— and, we hope, do it amazingly well. But that's skill, not style. To develop your own color style—an approach that gives identity to your work—you have to be consistent about what you want to say and consistent in the way you say it. In other words, your style will be defined by your story, the content of your painting, or by the graphic language you use to tell it.

Style often begins with conscious imitation. We imitate a painter who is saying something close to what we want to say or using a particular language we respond to. Identifying what qualities or approach make that painter's work distinctive is the first step in defining your own style.

Review this book and note which paintings and painters you most enjoy. Then try to determine what they have in common. Here are some questions you can ask yourself that may help you:

- Do they take a perceptual or a conceptual approach to color?

- How important to the painting is accuracy of color?

- Are effects of light and shadow an important part of their color approach?

- Does the pictorial space in their paintings seem deep, shallow, or flat?

- Are the forms in their paintings two-dimensional or three-dimensional?

- Does their color seem to convey a consistent mood?

As we have learned, artists often consistently limit in some way the values, colors, or intensities in their paintings. Ask yourself about the ways they may have done this to make certain qualities predominant in their work:

- Are their colors predominantly muted or intense?

- Are the paintings predominantly light or dark?

- Are the paintings predominantly warm or cool?

- Is the color range predominantly wide or narrow?

- Are their paintings simple or complicated?

Remember, artists' uses of color also vary according to the images or forms they use. The questions above are based on generalities, and the list could go on and on— no single answer would define a painter's color style. Yet by answering a number of questions you may begin to identify an appropriate direction for your own work. Of course, you may find a painter whose approach isn't consistent with that of other painters you've chosen as favorites. We often enjoy and admire paintings that possess very different qualities. That's natural.

You can enjoy different artists' work *without* feeling a need to imitate it, and it's just as well: You can't be Edward Betts in one painting and Alex Powers in the next. Imitation starts you in the right direction, but ultimately you want to be yourself.

Choosing Your Palette

"When we speak of the perfection of art," said the English painter John Constable, "we must recollect what the materials are with which an artist contends with nature. For the light of the sun he has but patent yellow and white lead—for the darkest shade, umber or soot." Times have changed. I have no such limitations as Constable spoke of. There are thirty-six paint wells on my palette and most of them are filled. Do you *need* that many colors (or even more) to fully express yourself? Probably not.

As a teacher interested in color, I try to experiment with as many different paints and approaches as I can. But as a painter, I rarely use more than six or seven colors in a single painting, and no more than sixteen regularly. The rest are what I consider "exotic" colors—paints that have an odd consistency or color not easily obtained by mixing my regular colors. They offer nothing I really need. Depending on the approach, you may need even fewer than sixteen. Too many choices can make color mixing confusing; but too few can greatly reduce your color mixing possibilities.

Artists limit their palettes for several reasons— financial, physical, and artistic. Unless you have a bank account the size of Donald Trump's and a palette the size of a dining-room table, you won't be able to buy and use every color manufactured. Even if you have clearly defined your approach to color ("Traditional," or "Impressionist," and so on), you would not have a use for that great a number of paints.

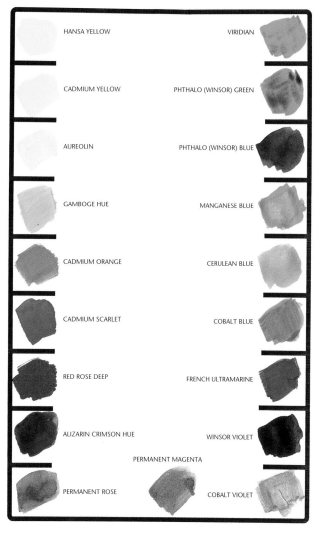

HANSA YELLOW	VIRIDIAN
CADMIUM YELLOW	PHTHALO (WINSOR) GREEN
AUREOLIN	PHTHALO (WINSOR) BLUE
GAMBOGE HUE	MANGANESE BLUE
CADMIUM ORANGE	CERULEAN BLUE
CADMIUM SCARLET	COBALT BLUE
RED ROSE DEEP	FRENCH ULTRAMARINE
ALIZARIN CRIMSON HUE	WINSOR VIOLET
PERMANENT MAGENTA	
PERMANENT ROSE	COBALT VIOLET

I've listed the colors of this full spectrum palette in the order that I would lay them out for my own work, but, of course, you can change that order if you prefer a different one.

Most artists limit their palettes primarily for convenience in mixing and for expressive reasons. For example, an artist who works primarily in bright, transparent tints would have little use for dark, premixed shades such as burnt sienna and burnt umber. On the other hand, a painter who characteristically employs a wide value range might find it more convenient to have these premixed dark shades on the palette. Mixing equivalents from pure, spectrum colors would take more time.

Here are some considerations, then, that might help you in choosing *your* palette. Ask yourself the following questions, and examine the specific suggested palettes.

1. *Do you want to use a variety of color approaches based on your subject or expressive intent? Or do you consistently work with one approach (such as "Turner" or "Bonnard" color, or some other approach we've discussed)?*
If you enjoy using a number of different approaches, you'll need the full spectrum palette to achieve a variety of effects. A full spectrum palette—one that consists of all the colors in a refracted ray of light—offers the greatest

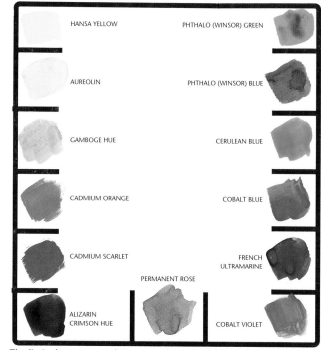

HANSA YELLOW	PHTHALO (WINSOR) GREEN
AUREOLIN	PHTHALO (WINSOR) BLUE
GAMBOGE HUE	CERULEAN BLUE
CADMIUM ORANGE	COBALT BLUE
CADMIUM SCARLET	FRENCH ULTRAMARINE
PERMANENT ROSE	
ALIZARIN CRIMSON HUE	COBALT VIOLET

The limited spectrum palette, a condensation of the full spectrum palette, will still yield a great variety of mixtures.

color-mixing possibilities and many varieties of pigment consistency. With practice, you can learn to mix the equivalent of almost any manufactured color from these pure colors. That is, by combining pure spectrum colors you can produce muted or shaded mixtures that closely resemble almost all the popular pigments, such as burnt sienna, sap green, and Payne's gray. However, you cannot transform a shade such as burnt sienna back into an intense orange. The full spectrum palette permits you to reproduce any color scheme described in this book.

If you're primarily a landscape painter, you may find that a *limited* spectrum palette is sufficient (and more portable, if you work outdoors), although you may want to add several earth colors such as raw sienna or burnt sienna for your convenience. A limited spectrum palette is just a simpler version of the full one described above. You can reduce the full spectrum palette to the essential colors (compare the illustrations) and still produce a great many mixtures and a complete range of values.

This is a more practical palette that allows you to work directly, mixing colors right on your paper (as in a wet-into-wet technique). It is also excellent if you want to paint with glazes of aureolin, permanent rose, cobalt blue, and cobalt violet—transparent colors that work well when applied in thin layers.

2. *Do you consistently work in a wide or a restricted range of values and colors?*
If you like to pull out all the stops and do paintings with strong value contrasts and intense color, you'll need a full spectrum palette. If you like subtlety and restraint, the *middle-value, muted palette* would be a better choice, which allows you to mix with control a great variety of colors with light- to mid-range values.

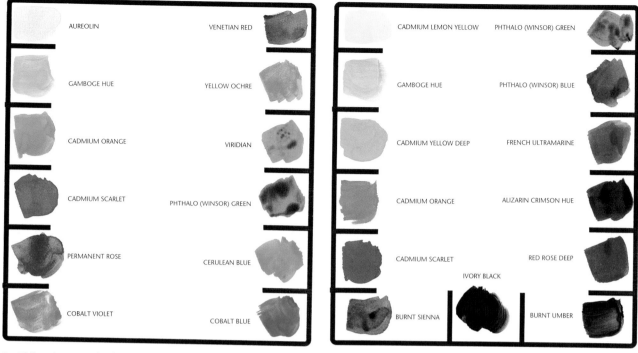

AUREOLIN	VENETIAN RED
GAMBOGE HUE	YELLOW OCHRE
CADMIUM ORANGE	VIRIDIAN
CADMIUM SCARLET	PHTHALO (WINSOR) GREEN
PERMANENT ROSE	CERULEAN BLUE
COBALT VIOLET	COBALT BLUE

CADMIUM LEMON YELLOW	PHTHALO (WINSOR) GREEN
GAMBOGE HUE	PHTHALO (WINSOR) BLUE
CADMIUM YELLOW DEEP	FRENCH ULTRAMARINE
CADMIUM ORANGE	ALIZARIN CRIMSON HUE
CADMIUM SCARLET	RED ROSE DEEP
BURNT SIENNA / IVORY BLACK	BURNT UMBER

A middle-value, muted palette is a selection of colors that are good for working with a narrow value range.

This full value palette features burnt sienna, burnt umber, and ivory black, with which you can easily produce deep, transparent darks.

This muted palette makes subtle adjustments in intensity easy. This palette will help you to work with the arrangements of values and intensity that we associate with the effect of luminosity (see pages 99–106). In his later watercolors, J. M. W. Turner used a very limited palette such as this. It contained a few light, pure colors and transparent colors that he called "aerial colors" (here, for example, cobalt blue, viridian, and aureolin), along with a few opaque, middle-value pigments that he referred to as "colors of substance."

With this palette, you can mix a great variety of muted tints and a full range of grays. Transparent and nonstaining pigments, along with permanent rose, which stains slightly, allow you to work by glazing and making subtle adjustments in value and intensity. However, this palette limits your value range and you won't be able to produce very dark mixtures. Thus, you'll find it almost impossible to mix deep shades.

3. *Does your color approach depend on contrasts in value, color, or intensity?*
The full spectrum palette gives you the greatest number of colors. Another palette I can recommend makes mixing darks easy. I think of this one as a *full value palette*.

This is a fairly traditional palette weighted toward the deep shades associated with, say, 17th-century Dutch painting. It will provide you with a wide range of light, warm colors and will allow you to mix rich, deep darks—the colors you would want if you were working with a wide range of values particularly. The palette includes dark stains—mainly, red rose deep, alizarin crimson hue, phthalo blue, and phthalo green—that penetrate your

paper's fibers. Using these colors and French ultramarine, you can mix a wide variety of deep shades. (If your approach depends on the intermingling of colors on paper, glazing, and the subtle adjustment of values, you'll find this palette unsuitable because of the staining colors.)

"Exotic" Colors
I can't resist trying every new paint that comes on the market. The names alone—geranium lake bluish, quinacridone gold—are novel or odd enough to convince me to buy them. I believe, just as students often do, that I've found the one color that will solve all my problems. Of course, that doesn't prove the case, and after a brief romance I discard it. Still, I do keep a few paints with a specific quality that can't be duplicated with my standard assortment. Some have pigments that granulate, or separate when mixed with other pigments, or stain, or produce glazes in some unique way. I don't use them often (and then only for very specific purposes), and I keep them in a separate area on my palette reserved for "exotic" paints.

Brands, Names, and Ingredients
You'll find all of the paints I've listed above available from a variety of paint manufacturers. Winsor & Newton, Da Vinci, Grumbacher, Schmincke, Holbein, Rowney, Sennelier, LeFranc & Bourgeois, Lukas, Maimeri, and Talens—these are some of the most reliable and popular brands. Is there any difference between them? Yes, because there is no standardization in labeling, in pigment consistency, or even in the ingredients used.

Two paints with the same name from different manufacturers might vary greatly in color, handling characteristics, and lightfastness. To list all the differences would be beyond the scope of this book, but there are several books devoted to listing the ingredients and permanence of watercolors that will guide you.

The paints you choose, whatever the color or brand, should be durable and permanent. In recent years, a good deal of research has been done on how reliably specific watermedia pigments will last once applied to paper and exposed to light, especially the rays of the sun. A number of old favorites have proven to be unstable or fugitive colors—that is, they fade or change over time. You probably should eliminate these from your paintings, before the effects of light and atmosphere do it for you.

Some of the paints I've listed in this book have traditional names followed by the word *hue* (gamboge hue, for example). Paint manufacturers will substitute an ingredient whose color closely resembles that of the pigment in a color (often a well-known color). This is done either to reduce costs, as is the often the case with the "student-grade" pigments, or to offer a more reliable and permanent alternative. For example, alizarin crimson and gamboge are notoriously unreliable pigments. However, alizarin crimson *hue* and gamboge *hue* (available from Da Vinci) are permanent and durable.

One other significant difference between the various brands listed is the proportion of pigment and glycerine, gum, sugar, and extenders used to make their paints adhere well, or make it thicker, and so on. Some brands of watercolor are extremely soft and runny (LeFranc & Bourgeois is one), others are stiff and almost gummy (Winsor & Newton). I prefer paints that are stiff, but *you* may prefer the gooey stuff.

The paints—and the palettes—I've suggested are intended to help you produce creative and expressive paintings in color. Although I have worked to make my ideas thoughtfully organized and fairly complete, they represent, nonetheless, merely my suggestions. You can, and probably will, by way of experimentation and experience add to, subtract from, or alter them to fit your personal approach to color.

RECOMMENDED READING

Betts, Edward, *Master Class in Watermedia*. New York: Watson-Guptill, 1993.

Birren, Faber, *Color Perception in Art*. West Chester, Penn.: Schiffer, 1986.

Brandt, Rex, *Seeing with a Painter's Eye,* 2nd ed. New York: Van Nostrand Reinhold, 1984.

Feldman, Edmund Burke, *Varieties of Visual Experience*. New York: Harry N. Abrams, 1992.

Gage, John, *Color and Culture*. Boston: Little, Brown, 1993.

Lawrence, William, *Painting Light and Shade in Watercolor*. Cincinnati: North Light, 1994.

Loran, Erle, *Cézanne's Composition*. Berkeley and Los Angeles: University of California Press, 1943.

Powers, Alex, *Painting People in Watercolor*. New York: Watson-Guptill, 1989.

Ratliff, Floyd, *Paul Signac and Color in Neo-Impressionism*. New York: The Rockefeller University Press, 1992.

Reep, Edward, *The Content of Watercolor,* rev. ed. New York: Van Nostrand Reinhold, 1983.

Schink, Christopher, *Mastering Color and Design in Watercolor*. New York: Watson-Guptill, 1981.

Wilcox, Michael, *Guide to the Best Watercolor Paints*. Perth, Australia: Artways, 1991.

INDEX